— Editorial —

Issue five of *The Happy Hypocrite*, themed What Am I?, is not quite as it looks.

Garbed in a sequence of paradigmatic structures such as the joke, the notebook, the novel and the script, this issue's range of contributions is none of these, for they defy the innate obsolescence of such classification through their own inner logic(s). As anthropologist Edmund Carpenter has it, 'Form came from choice, not limitation. No borders froze, imprisoned. Instead, each mobile, obedient to an inner impulse, created its own dimensions…'

What then are these writings? Enjambment of form is my own, very deliberate, editorial action of self-regard, pointing to issues of readability and usage in contemporary art writing. For today is an important moment in the fight against documentational notation, we must continue to support analytical and poetical reasoning.

The voiceover at the beginning of Pasolini's 1969 film *Porcile* declaims, '…After a thorough examination of our conscience we've decided to eat you because of your disobedience.'

Well, I've decided to publish instead.

— Maria Fusco

— Contents —

1
Editorial
Maria Fusco

4
Say What You See
In which The Happy Hypocrite invites someone
to describe something visual in words.
Moroni Olsen is Dead – Shumon Basar

6
Interview
In which The Happy Hypocrite brings
people together to discuss the issue's theme.
What Am I? – Chris Kraus and Maria Fusco

16
Miniature Essay
In which The Happy Hypocrite invites
someone to write 500 words or less on a
contemporary topic of their choosing.
Poem – Seth Price

18, 20, 22, 24,
Aide-mémoire: ringing ear
Aide-mémoire: ear ring
Aide-mémoire: stone age burial
Aide-mémoire: bronze head
Sarah Tripp

26
Backword
Laure Prouvost

35
The Preparation of the Novel
In which Kate Briggs translates
Roland Barthes' *La Préparation du roman*

41
Κόσμος;
after Dalton Trumbo
Antonia Hirsch

48
There are 36 ways to view Mount Fuji
Hanne Lippard

50, 53, 54
Disingenuousness
Doctor Faustus (after Corinth/Steinberg)
Writer's Rooms #1: David Hare (after Steinberg)
Stephen Sutcliffe

57
The Future's Getting Old Like The Rest Of Us
George Clark and Beatrice Gibson

71
Paper Machine – The Plebs
In which The Happy Hypocrite reprints
a seminal printed matter.
Selected by Ruth Ewan

Moroni Olsen is Dead – Shumon Basar

Say what you see

A Rather Large Weapon – Bernadette Buckley

Love Canon is an installation work by Walker and Bromwich, which was inaugurated in Les Arques, France in 2007. The work is part of Walker and Bromwich's *Friendly Frontier Peace Campaign*, devised by the artists to 'celebrate love through actions and environments'. Despite its tranquil atmosphere, the village of Les Arques is steeped in a history of medieval battles, the latter of which are still visible in its fortified architecture. Since its opening event in France, *Love Canon* has been fired at numerous locations across the UK.

OK.[1]
I EXAMINE just in case a flat surface can stow away unlit corners. Where time settles like dust unseen.
I SWEEP across every square centimetre. A scanner.
I PEER further.
I SMELL deserts, sands, sky, silica.
I FEEL the heat of factory furnaces.
I FAIL to pronounce the names of Chinese cities whose furnaces burn fiercely.
I INHALE the air that's expelled from factories.
I WONDER about purification processes, quality control, floor managers, *Tout Va Bien*!
I SEE a material's history.

I LOOK.[2]
I ADVANCE my gaze.
I COUNT three faces. Assemblages of distinct anatomies. Possibly related? Surely never.

I AM looking.[3]
I OUTLINE the textures in front of me. Minor craters. Expired skin shored up against live skin. Many years striving against boredom – now, dermatological facts. There's former glory, mine, gone. Against the fascism of youth! Sun spots. Black spots. Spots to come. Smears. Evidence of caring too much. And, then, never enough when it really counted. A sort of history written in rips, infractions, blemishes and flakes.
I BORE into the two brown spots closest to me. Eye. Eye.
I RECALL something an artist once proposed. She said,[4] 'Look directly into someone's eyes for more than four minutes and you catch a glimpse of who they really are. What they cannot hide. The glitter, the shimmer, the sadness, the dirt. The ache of possessing a body. The ache of not possessing someone else's body.'

I DON'T LOOK[5] now.
I QUOTE Hannah Arendt quietly, 'Pain is the least communicable of all.'
I CITE Walt Disney purposefully, 'We cannot do the fantastic things based on the real, unless we first know the real.'

I RE-LOOK:[6]
I RE-OUTLINE another face entirely composed of outlines. Furrowed frown. Thick eyelashes. Lips turned upwards. Arms folded. Red nails to match her mouth. A crème sail around her neck, tied together with a golden amulet. Lilac gown. A black head stocking. Her crown dulled. Its sheen unshining. Arms folded. Fed up. She's pissed off. Furious. Hurt, lost. She's never felt like this before. What else did she have going for her? Kindness? Wit? Charm? She wears a frown of death. The scene darkens as she seethes with jealousy. Intercut between gothic interiors and pale watercolour landscapes.[7]

I LOOK to see if someone else is looking.
I DARE not stare at the green face floating in the green smoke. But, I have to. His shadowed features sulphur yellow. Those pointy ears, so puma-ish. No eyes I can make out. Floating in fate's smoke. He's got the inside information, his ears to the ground. He speaks: others listen. I have to look at him. Trapped in a surface, the one that gives him auth ority. The very surface that makes him a total loner. Did he used to have friends? Did he used to have a neck, a body? Arms with which he could embrace? Hips with which he could thrust? Lips. Did he ever have lips? Not these raggedly strips of taut nothingness, floating in a deep, green algae soup of paranormal flatness. Did he ever love her?

I SEE a history in material.
I SEE a history of looking at looking.
I SEE the book killing the building,[8] video killing the radio-star, television killing cinema, video killing TV, TiVo killing the video recorder, the iPad killing the book.

I BET Moroni Olsen is dead.

[1] *Downcast Eyes,* Martin Jay (1994)
[2] *Eye and Spirit,* Maurice Merleau-Ponty (1961)
[3] *Seduction,* Jean Baudrillard (1979)
[4] Marina Abramović via James Westcott
[5] *The Four Fundamental Concepts of Psychoanalysis,* Jacques Lacan (1998)
[6] *The Vision Machine,* Paul Virilio (1994)
[7] *Seven Minutes,* Norman M. Kline (1993)
[8] *The Hunchback of Notre-Dame,* Victor Hugo (1831)

Chris Kraus and Maria Fusco talk about What Am I?

MF: (Maria Fusco) Hello Chris.

CK: (Chris Kraus) Hi Maria.

MF: Maybe we will speak for an hour?

CK: And then we'll completely rewrite each other…

MF: Great! I've borrowed, well I've stolen the theme of this issue from 'Lyric Substance: On Riddles, Materialism, and Poetic Obscurity', an article by academic and poet Daniel Tiffany, which discusses 'riddlic inscription'. I've found his text really useful in thinking through how to 'write' objects, in that we must approach them with their own logic so to speak. Now, this leads me to think about your writing, as much of your work lives within and of course directly references your experience with contemporary art. How is the stricture of a life in art useful for you as a writer?

CK: (Misunderstanding the question) formal strictures, oh yes, they're really helpful! My book *Video Green: Los Angeles Art and The Triumph of Nothingness* was easy because I'd been asked to write a column for the magazine *Artext* that lived between LA and Sydney. The column had to be 1,500 words each time. There's great freedom in that kind of writing, unlike an essay or an art review, a column can be a record of just walking around, looking at art filtered through the moment, that time; that time as you're living it. So I took that invitation pretty literally. I never thought about the column (it was called 'Torpor') in advance, three days before it was due, I'd look around and start to think about it. Since the magazine invited me as a writer, not an art critic, there was no pressure to be fair or balanced. Of course I only wrote about work I liked. The column as part of how I was living, where I was living then – *about* how I was disposed to look at things, so I just kind of let that come through. I was very much asked to do it as a writer, as opposed to an art critic, so that also gave me the freedom not to have to be comprehensive, fair or reasonable (in that curatorial way) to talk about how the art was looking and meaning to me at that time, as I saw it.

MF: I find the modularity of that type of column writing when it's brought together into a book form like *Video Green* very appealing and easy to read – in a good way – as it allows me as reader to move across the text, to cross-reference, to choose to leave things out if I want to.

CK: As opposed to a book with a clear line of argument?

MF: Yes, very tedious…

CK: Isn't that weird? All the art books that I like best too are also separate pieces.

MF: How about this in relation your role as an editor? Both in terms of course of how you edit your own writing, but also in how you originally put together Semiotext(e)'s Native Agents series?

CK: Since 2001, when Hedi El Kholti joined Semiotext(e) as co editor, we've blurred the lines between the imprints, somewhat. Native Agents is still fiction, but it's just as likely to be commissioned and edited by Hedi as by me. Likewise, some of the books I've worked on lately have been for the imprint Active Agents currently we're seeing that imprint as a forum for new critical writing, as well as other things. But when I started the Native Agents series in 1990, it was with a very clear agenda...

MF: I can't tell you how important the series – certainly at least the early books – was here in London, massively culturally significant within 'reading' art. I remember when I used to run the bookshop at the ICA, that little series of yours always used to get stolen, always!

CK: Oh, I'm so glad.

MF: We used to have to keep them literally locked away in a glass vitrine. Like Snow White...

CK: I wish you had a photo of that! The series was really urgent – a set of little coloured books... the girls... to counterpoint the big bad black theory books. Initially, all the Native Agents books – except for David Rattray's *How I Became One of the Invisible* – all of them were by female writers and were written in the first person. My intention was to produce a female, first-person fiction series that could NOT be misread as memoir. I didn't make this up, it was very much in the culture but I wanted to politicise it, make it more visibly a statement. Actually it could be said that all of Semiotext(e)'s work is a manifesto. The early Native Agents books, written by Cookie Mueller, Eileen Myles, Lynne Tillman, Barbara Barg and Kathy Acker, all featured a very public 'I' that was outward looking and aggressive: the texts could be autobiographical, but NOT memoir because the subject 'I' itself is never the real subject. To this day, women writing first person fiction are still subjected to this awful, memoir-istic reading of their work, as if female experience itself were so troubled the female 'I' could ONLY be intensely self-reflective! I remember editing Michelle Tea's first book, *The Passionate Mistakes and Intricate Corruption of One Girl in America*, that came out in 1998... going up to San Francisco and hanging out with her at her place in the Mission, talking about the book for two or three days. Originally the book was a group of disconnected stories, and I said, 'Oh. You want this to be a novel.'

MF: How did you go about making it work in that form?

CK: It's not hard, I just put the stories in chronological order and made a few connections. Michelle was like, 'But everything I write is true! And that wouldn't be authentic!' In fact, the book was totally authentic, the novelistic structure just made the book more readable. The trajectory becomes two or three years in the writer's early life, from high school Goth to the months before she moved to San Francisco and became Michelle Tea. The recurring characters are compelling, but Michelle is a fantastic writer, and mostly you want to see things through her eyes. Editing other people's books, I try and be the best possible reader of that person's work.

MF: As an editor then do you have to feel that you're right in order to be able to finish the book?

CK: Yeah, you can feel you're right, but sometimes you're wrong! I had that experience with Eileen Myles' recent book, *The Importance of Being Iceland*, I really wanted it to be shorter. I wasn't seeing it

as it turned out to be. I thought Eileen Myles was doing an art book, I thought 'That'll be good, it'll be a new colour in her palette, an art book' – not travel writing, not talking about Allen Ginsberg – which would have made a much shorter book. Eileen was against that. She did make the book a little bit shorter, but she didn't want to make it a lot shorter, she was completely adamant about that. We had a big fight. At the end of the day it's the writer's call, always. I'll do my best job at giving my *read*, but it's their decision. Eileen's decision was not to make it that much shorter. And she was right! Because it's not an art book! It's an incredibly successful book, widely read and reviewed as the book that elucidates her theory of poetics. *Iceland* is a manifesto of Myles' work as a poet, fiction writer and more than a cultural commentator, an important presence in culture. In *Iceland* she beautifully explains how the discipline of her life as a poet informs how she sees art, how she writes – how she lives her life. All the pieces in the book talk to each other.

MF: If everything talks to each other, can seriality help generate conversation?

CK: By seriality do you mean like, a recurring theme or phrase?

MF: Well, yes and no. I think I'm thinking here about the odd word or nest of words that pop up to remind you that you are reading, and what you are reading, to help you map a book. But also more generally, a series of books, ongoing...

CK: When we started the Native Agents series, we brought them out in clusters because we wanted them to narrate and inform each other – the first cluster was Cookie Mueller, Kathy Acker, Eileen Myles and Ann Rower – we wanted those books to bounce off each other. That was very important especially in female writing, which unfortunately is almost always perceived as singularity and never as a group or school.

MF: Also this promotion of the use of first person? Its potential for 'militancy'?

CK: Perhaps even more radicalising than the use of the first person is the use of real time that these writers share. It's something I inhaled by reading them, and it came to include my first novel, *I Love Dick*. Writing something as it happens immediately makes writing very physical, ideas are grounded by the fact they're being thought by a person, at a particular time and place and that gives a very direct communication with the reader.

MF: What's your expectation as to how the reader would respond to that?

CK: Best case, they just feel like you're talking to them late at night on the phone… It's the most intimate, compelling thing. Like… I love reading people's diaries, from all periods of history.

MF: Diaries… I'll read you back something you wrote in *Video Green* about handling Antonin Artaud's notebook.

'We passed the notebook around. Jim, an actor and translator, read some pages out loud. As Jim read, there was a definite spark — as if some kind of transmission was happening between the marks Artaud had made on these pages, and what went on in Jim's eyes. The notebook made Artaud seem incredibly human. No more mythic hero… The grandiosity of Artaud's writings suddenly shrank to

something more troubling... just a guy writing a notebook. Artaud became our missing friend because his notebook could have been one of ours.'

I love the way you transform disappointment into potential here. I recently read a phrase I like from Michel Serres, 'All authors are our contemporaries': this counter-intuitive temporal space of writing (and reading) seems to me really present in your observation about that Artaud notebook.

CK: Maybe not all writers, but certainly all *good* writers are our contemporaries.

MF: Where (and how) are you within that?

CK: Well, it's a very happy place to be! Even as a reader – forget as a writer – the very act of reading makes these authors your contemporaries. Reading any kind of good writing alters you in the present.

MF: An intense experience?

CK: Yeah but not TOO intense. That modernist idea of intense experience leads to feuds, hatred, excommunications. Like the surrealists and situationists, Breton and Debord. Now of course everyone's so busy, most feuds are forgotten in a couple of days... nothing seems THAT important, which is great and of course tragic, too.

MF: For some research on a screenplay I'm writing at the moment, I was looking again at *Project for a Film by Kafka*, an unrealised mini-series by Félix Guattari, where he's trying to think how he can write *through* or again *with*, or again *by* Kafka. What do you think about this idea of writing *through*?

CK: Writing *through* another writer is something everyone will always do. Here, this book I've brought with me, Bifo's *The Soul At Work*, which I think is a great great book, addresses the issue's question, 'What Am I?.' Bifo is writing back to Guattari. He was a younger associate of Guattari – maybe a disciple or acolyte, I don't know – but he champions Guattari's work, drawing aspects of it into the present. Bifo's observations about the post-capitalist life speak completely to the present, but they're informed by work on sadness and subjectivity that Guattari had started in the last part of the century. The fact of Bifo's work occurs in dialogue with Guattari.

MF: What do you think about groups?

CK: Little groups are great.

MF: Yes, little groups are great. Big groups are a nightmare, but I digress. I saw an interview on television with Larry David, where he said – I'm paraphrasing – that it's the bad thought that makes the good work. I remembered this observation when I read the chapter you sent me from your forthcoming book *Summer of Hate*, one of the characters, Paul says 'There was always one shoe waiting to drop. Good things made him feel queasy.' I'm trying the think through how critique and the bad thought are very close to each other...

CK: Critique as a charged form of observation?

MF: That's it. This 'observation' as a puncturing action, like humour?

CK: How I use humour results from looking at something as I see it, in opposition to using the rhetoric given to me: often there's a great discrepancy between those two things and that's just automatically funny. Of course the more you put yourself out on a limb, the funnier it becomes, because it's so relatable, and in turn the further out you go on a limb, it just gets funnier.

MF: For me humour and boredom are very linked. Here I mean 'legitimately bored' rather than short attention span bored.

CK: Yes! Legitimately bored because what you're looking at is really boring! ADD is the last frontier of resistance to the static of the culture!

MF: You have to make it interesting for yourself…

CK: Absolutely, if there's a live quality, then it's not boring. A sensitivity towards boredom is a great thing.

Extract from *Summer of Hate*

Dear Dr. Delaney,
(Paul wrote to Chair of the UNM Psychology Department)

I am interested in Psychology because I want to gain an understanding of the way people's minds work. I am also interested in it because I think that due to my experiences I am in a position to help other people with substance abuse and alcoholism.

I grew up with a mother that was severely mentally ill. She was diagnosed with 'manic depressive paranoid schizophrenia.' Needless to say, it was a very tough environment to grow up in and as a child there was nothing I could do about it. Now that I am an adult – while there is still nothing I can do about it – I would like to try to understand it better. I think that if I can understand mental illness in its various forms, I can maybe understand me better. I can understand why I feel the way I do inside and why I've had the life I've had. Through this understanding I might be able to help others as well. Growing up was terrible and the only thing that took my mind off of the everyday chaos was alcohol. I started drinking when I was sixteen years old.

The other reason I would like to study Psychology is that I would like to become a substance abuse counsellor. I am in fact, an alcoholic that has been in recovery for nearly three years. Since I was sixteen I drank to escape. I drank to get drunk and not have any feelings. Little did I know I was just postponing my feelings so to speak. I started getting into trouble with the law shortly after that and this began my 'colourful' history

with it. I got into fights, got DWI's and other non-violent crimes. Finally I ended up going to prison for two years and am now on parole. I am very happy to be in recovery and I think that I can help others to get into recovery. It has been my experience that most people with addiction problems are more ready to listen to someone who's 'been there.' I realise that there is still plenty to learn and I would like to do that in order to become a counsellor to help others.

I am getting ready to turn 40 years old in May and I guess I've done some growing up. I am very serious about getting an excellent education and I feel like I need to do graduate work in order to try for a PhD. I think this would be good for me so that people will take me more seriously when I apply for a job and also when I counsel. I also have hopes of writing, and I think this would help in that area. I am planning on applying to graduate school at UCLA. I am lucky enough to have friends there and my girlfriend is also based in LA which makes things easier for me as far as support and a place to live.

My goals for a career are to become a substance abuse therapist and also a writer. I think that since I have a unique history and since I am an alcoholic, I will be able to touch people in a way that perhaps others can't. If by writing, or through therapy, I can change just one person's life, I'll be happy. I will feel like I've accomplished something. I am sorry this application is late. I have no excuse. Thank you for considering me.

When Paul called Catt at her visiting faculty apartment in Chicago last April and read this over the phone, she had a fit. She was leaving in two days to give a talk

in Australia, there were student essays to read and a letter had just been slipped the door from the management office saying it had been *brought to their attention* she was keeping a pet and if the pet wasn't gone in a week she'd have to vacate the apartment. 'Oh Paul,' she sighed. 'He's not your parole officer. You can't submit that if you want to get in.' How could he have gotten straight A's since starting school in September and write such a letter? But then: writing and thinking weren't on his curriculum, it was all multiple choice and memorisation. She was sorry that college ended up being like this. Which was why she'd come up with the idea that he might take summer classes at UCLA and apply for the Honors Program. She was worn out. Let other people take over.

'Well kitten I'm at a loss! I don't know what to do. Could you give me some help?'

Of course the letter was touching. But where do you start? 'I want you to try and talk like a smart person,' she liked to say to the shy sullen girls who signed up for her classes, and they laughed and got into it. She'd taken a *NY Times* subscription for Paul but the only stories he read were the ones about serial killers. He was highly informed about the difference between killing sprees (which were cool, but not very creative) and serial killing. As a rule, serial killers had impressive IQs, whereas the guys who went out on killing sprees were simply angry. In either case, the killings occurred in a void when the killer's rational mind just blacked out, and this was very attractive.

'Alright,' she said, clearing her desk. 'Give me 25 minutes. I'll figure it out.'

Dear Dr. Delaney,
(Catt wrote as Paul)

I entered UNM last Fall to study psychology with the goal of becoming a substance abuse counsellor and psychotherapist. Etcetera. She could write this shit in her sleep. Eventually I hope to write a PhD based partly on clinical practice that will prepare me to shape new treatment models…

Poem – Seth Price

Miniature Essay

– Right, industrialization is spreading everywhere.
– Yes, and it is possible that the Soviet Union converged with the Third World, not the West.

– Well, the 3rd world, or, let's say "the poor", are not so much exploited as simply passed over, neglected. ?
– (Rising sea levels, etc.) –
– What? – Well, flooding many coastal cities, for one. Damaging arable land... Etc
– Like how "poor" women may carry around their stuff in a plastic bag from a "nice" store, for months

Aide-mémoire: ringing ear

1 On the DESK are a
 pair of HEADPHONES
 and a PEN
 but no PAPER.

2 I put the headphones on
 A DISTANT voice speaks to me.

3 It says,
 'Please tap the pen on the desk
 when the sound DISAPPEARS.'
 I nod in agreement.

4 A beautiful, clear tone appears,
 I follow its PROGRESSION
 to a FREQUENCY that is INAUDIBLE.
 I tap my pen and look up
 to see if I'd got it right.

5 A HIGHER tone appears,
 then moves further away from me
 becoming THINNER and FINER.
 SILENCE.
 I tap the pen.

6 Another tone,
 like a SINGING GLASS
 rises higher and higher,
 RINGING in my ears,
 until I can no longer tell

7 if the sound is still there –
 OR if I'm only imagining it.

8 if the sound is still there –
 OR if I'm only imagining it.

9 if the sound is still there –
 OR if I'm only imagining it.

10 if the sound is still there –

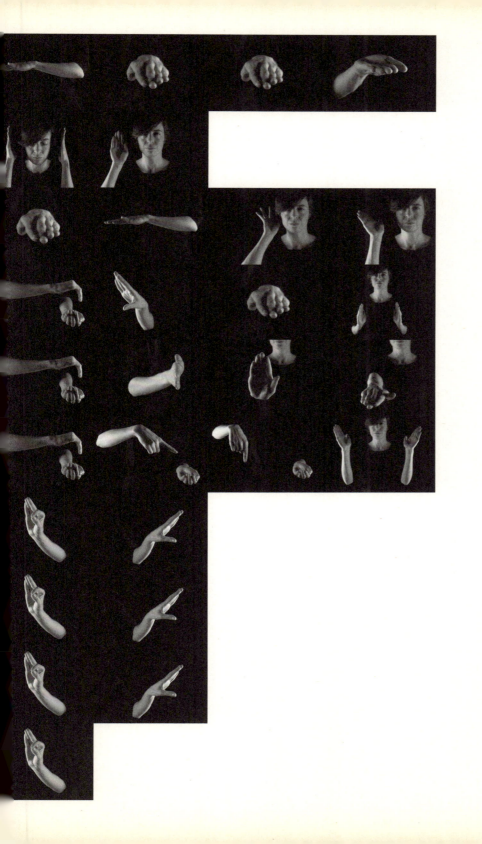

Aide-mémoire:
ear ring

1 I listen carefully to the STRANGER.

2 She wants:
 DIRECTIONS to the bus stop
 and a
 POUND for the bus.

3 The pierced hole in her RIGHT EAR
 has RIPPED and HEALED into a
 pointless flap.

4 In her LEFT EAR hangs a
 HOOPED ear ring
 LOOPED together
 with its spare partner
 for safe keeping.

5 I point LEFT to the bus stop.
 She studies my face,
 and walks off to the RIGHT.

6 I point LEFT to the bus stop.
 She studies my face,
 and walks off to the RIGHT.

7 I point LEFT to the bus stop.
 She studies my EMPTY HANDS,
 and walks off to the RIGHT.

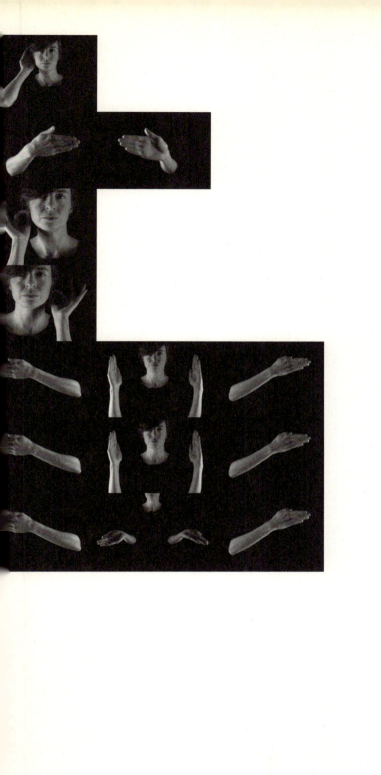

Aide-mémoire: stone age burial

1 Dust SNAKES along the ground.

2 A lattice of yellow plastic tape
 FLICKERS in the wind.

3 I step over the tape
 and onto the RAKED
 and SIFTED soil.

4 I look down into a
 HOLE HEWN in the ground.
 THERE, clasped by dry earth
 are four STONE AGE SKELETONS.

5 SOFTLY BRUSHED
 mounds of earth
 hold each bone in place.

6 A MALE skeleton faces
 A FEMALE skeleton.

7 Between them lie the
 SMALL SKELETONS
 of TWO children.
 Each child embraces an adult.

8 The skulls are
 VOID of EXPRESSION but the
 arms are still entwined with
 AFFECTION.

9 I lower my head and turn away –
 EMBARRASSED.

10 AS IF
 I'd stumbled in on
 sleeping strangers.

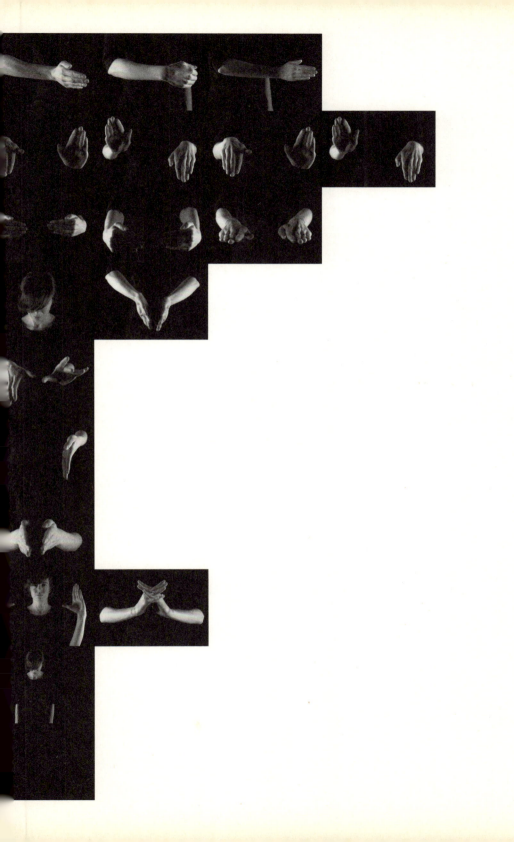

Aide-mémoire: bronze head

1. On the FRONT of the postcard
 is a BRONZE HEAD
 of a roman-looking man.

2. On the REVERSE
 is a SIGNATURE I can't decipher
 crossed with a kiss.

3. There's NO MESSAGE,
 just a white, empty space where a
 message should be.

4. The postcard is sent from ROME,

5. where I have no friends
 OR family,
 holidaying
 OR living.

6. The postcard seems to be here to
 DRAW my attention to

7. SOMETHING,
 rather than SOMEONE.

8. Maybe it's here to remind me that the
 people I've FORGOTTEN
 might not have forgotten me.

9. OR, it's to remind me that the people
 I know well, sometimes want to be
 ANONYMOUS.

10. EITHER way,
 I think twice.

I was just walking down the street,
and i saw this lady falling into a hole by roadworks.
A hole the side of her, about the size of a coffin but deeper.
A big truck was just about to pour in some tarmac, i could see the
tarmac going down starting covering her.
She started moving screaming and getting covered of the stuff.
I try to give her a hand but she did not want a help, she was very
angry, screaming, trying to climb by herself.
She manage to pull her trolley back up,
she was covered of tarmac, completly black now.
The trolley was full driping black everywhere.
She told everyone to move on there was nothing to see,
she run off down the street

It was so nice our friends lend us there cotage for holiday. We had such a great time there place is so lovely, she had told me to be carfull at the vase her gran gave her. It was so upseting as soon as we arrive goerge with his ballon boke the vase staight away, i was looking in all the shops for the duration of the holiday to find something similar, at the end all i found was a blue square vase, i dont know what she is going to think, we had to move the sofa our cat is distoyed so, i cover with nice indian sheets, the light bulb broke, mark had put some blue paint on the table so we though best was to make it nice so we made dots every where on the walls too it looked pretty nice.

[surrounding handwritten annotations in French and English, partially legible:]

c'etait sympa nos amis nous on prêter leur maison de vacances c'etait extra leur maison est excellent charmante... on a fini... on a vol un peu... on a bu beaucoup... Green Blankets... quand on est arrivé george avec son ballon... tout le vase en céramique... c'est un vase bleu carré... on a pris une piece of wood to repair... used the table to... the sofa but made a hole in the table, we have put a book on top but we glued it to to the table i hope he wont realise... with a big chandelier from the ceiling... a Big Biggg...

the place we are staying looked a little bit like this. But the colors... they was real tiles... A they was not so... a present we bought... present then a better picture... taller + Bigger... a strong pink... a lot Bigger...

on Big Ben

Tou, Tou Tou
tou tooouuuuuuu touuuuuuuu touuuu, touuuuuuuuuu
tou tou tou
touuuu touuuuu touuuu enfant de la patrie,
tou tou le jour de gloire est arrive...
tou tou tou tou tou tou touuu tou tou touu tou tou touu
touuuu touuuu, tou tou tou tou
tou tou aux armes citoyens,
contre nous de la tyrannie tou tou touuuuuu,
touuuuuu tou tou touuu!

trompette,

£400 × 12 = 4000

Realy load noise

everything
glasses
pleasser / Radiation ne mijer tres
£9500 for the window compatissante
+ Roof +

Here i could not find the picture i wanted to show you,
it was the most amazing flowers, full of petal of amazing
diferent colour, there was just at that point a beautifull
butter fly, blue and green on it.
And in the back a tiger was just passing by folowed by its
little one and in the disctance you could just see a girafe.
I am so upset not to find it aany more.
I cant belive i lost it.

A picture that would win prices.

picture I ever took evything see it to have one gather

the ocean vador on the right the sea a shark about to get a person surving the most beautiful a lion the back growing 2 lion fighting a man jumping in the air a balloon flying past in the far distance a more strange things monkey in the beach eclipse of little further who just stole someone hat the most Beautifull water fall ever one day is far 30mel a night a donkey jumping other a fence and a couple in front of the sunset kissing pasionatly blue butter fly flying all around them.

(sicily. in may)? (also with)

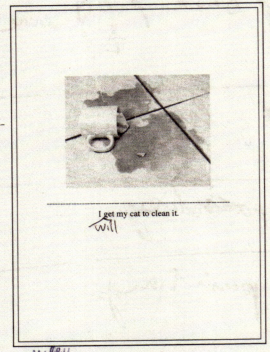

I get my cat to clean it.
will

every in the morning my
husband do that to wash we luck.

My friends,
this is a picture we took after we went on
holiday by bus ~~around the world~~ NO-one
A nightmare, ~~none~~ could stand one another,
scratching, pulling each others hairs all the time.
Never again, too much stress
although they look pretty inocent there.
To thank me at the end they made this huge painting
~~for me, i don't know what to do with it~~ it is horrible
~~if you want it you could have it.~~
~~Just call me we will arrange for delivery.~~

They ~~said~~ told me it was an interpretation of

our trip, ~~and said it~~

would look great in ~~our~~ my next show.

of us

~~No one~~

~~He loved each other so much~~
a- The next day she was pregnant

b- He did bit her up later that night.
she did end up in Hospital

Mark took the lawn cuter his morning as i was not looking, he came in the house with it, cut the carpet off so short, got the telephone in it, the cat too, our computer, most the books, on the othere side of the phone someone was screaming, i could not answer, i hope it was not something bad.

La Préparation du roman — Roland Barthes

translated by Kate Briggs

(extract from) Session of December 16, 1978

1. As If

Will I *really* write a Novel? I'll answer this and only this. I'll proceed *as if* I were going to write one ⟶ I'll install myself within this *as if*: this lecture course could have been called '*As If.*'
Comments:

Risk.
Nothing left to lose

a) People will say to me – it's been said to me: by announcing it, you're taking a huge risk, a 'magic' risk. To say something out loud, in advance, is to destroy it; to designate too early is to attract bad luck (Don't count your chickens[1]). Ordinarily, I take this kind of risk very seriously; I never allow myself to talk about the book I'm going to write. Why am I risking it this time and *provoking the Gods*, so to speak? Because the risk is bound up with the mutation I spoke of (Middle of Life's Journey): that mutation effectively involves the consideration of a kind of *Nothing left to lose*. That's in no way the motto of a 'desperado', but rather of the search for a considered counterpoint to an expression that's so French (which haunts the conduct of the French): 'to lose face' – French culture being more a culture of shame than of sin. Whether or not I write a novel, whether or not I fail in my attempt to write one, this isn't a 'performance' but a 'path.' To be in love is to lose face and to accept it, hence there's no face to be lost. – Moreover:

To be in love: is to lose face and to accept it

Method

b) *As if*: the motto of *Method* (a particular way of working used by Mathematicians). Method = the methodical exploitation of a hypothesis; here, as you'll have grasped: a hypothesis not of *explanation* (of interpretation) (meta-Novel), but of *production*.
c) Method = path. (Grenier, Tao = Path.[2] Tao is at once the path

[1] Barthes writes '*La Peau de l'ours*' from the expression '*Il ne faut pas vendre la peau de l'ours avant de l'avoir tué*' ('Don't sell a bear's skin before you've killed it'); an equivalent English expression is 'Don't count your chickens before they hatch.'
[2] Jean Grenier, *L'Esprit de Tao* (Paris: Flammarion, 1957), p.14.

	to be travelled and the end of the journey, the method and the accomplishment. No sooner have you set out on the path than you have already travelled its length). Tao: what matters is the path, following the path, not what you find at the end → The Quest of the Fantasy is already a Narrative → 'Begin, even without hope; proceed, even without success.'³ (It's *also* a Sartrean saying).
Path, without end	
Grand nostalgic theme	d) It's therefore possible that the Novel will remain at the level of – or be exhausted and accomplished by – its Preparation. Another title for this course (which will probably go on for several years, circumstances permitting) could be 'The Impossible Novel.' In which case, the labour that's beginning = the exploration of a grand nostalgic theme. Something lurks in our History: the Death of literature; it's what roams around us; we have to look that ghost in the face, taking *practice* as our starting point → it's therefore a question of *tense* labour: at once *anxious* and *active* (the Worst is never certain⁴).

2. Ethics / Technique

Technique	Since this Course will involve investigating a practice, there'll be some *paratechnical* issues to consider (and one technique in particular: literary) → Risk that you'll be disappointed, that some of you won't find it interesting: disappointment that I'm attempting to ward off by naming and anticipating it → At first, the register will seem completely different to last year's: *Neutral* = *ethical* category: there's no 'technique' of the Neutral, other tha n in Tao.
	And yet: it seems to me that each thing – every action, operation, intervention, gesture, work – has three aspects to it: technical, ideological, ethical → The ideological aspect of this enterprise isn't for me to decide, it's for others to identify: The Ideological is always Other People.
Aesthetics / Ethics	But it's my hope that this labour will be undertaken at the undecidable point where the Technical and the Ethical meet. And if we consider the fact that, when it comes to writing, a Technique presupposes an Aesthetics, then this labour (this Course): situated at the point where the Aesthetic and the Ethical intersect, overlap. This is a Kierkegaardian problem. *(Either/Or)*. Let's articulate
Kierkegaard	it (and correct it) with Kafka (in conversation with Janouch): 'Kierkegaard faces the problem, whether to enjoy life aesthetically or to experience it ethically. But this seems to me a false statement of the problem. The Either-Or exists only in the head of Søren Kierkegaard. In reality one can only achieve an aesthetic

³ Saying attributed to William the First of Orange, Count of Nassau (1533–1584) who instigated the Dutch uprising against the Spanish.
⁴ {Barthes writes *'Le Pire n'est pas sûr'* referring to the expression *'On peut s'attendre au pire, mais le pire n'est jamais sûr'* which translates as: 'We can expect the worst, but the worst is never certain.'}

Craft and General Conversation	enjoyment of life as a result of humble ethical experience.'[5] The 'Technical' is basically the moral and humble experience of Writing ⟶ not, in the end, very far removed from the Neutral. Will it interest you – even those among you who don't write, or those among you who do, but who aren't plagued by the same problems as I am? My hope rests on personal experience: I never tire of hearing people talk about their craft,[6] the problems they come up against in their work, *whatever it is they do*. Most of the time, unfortunately, people think they're under an obligation to engage in *general conversation*. How many times have I been irritated and frustrated by a conversation – that others make 'general' – because a specialist whom I'd dearly love to hear discuss his specialism starts making banal cultural or philosophical remarks when he could be telling me about his craft! – Intellectuals in particular never discuss their craft, as if they didn't have one: they have 'ideas', 'positions', but no craft! The amused and indulgent irony with which Rambures's survey was received (by him, by the way).[7] What? These writers who pay attention to which pen they use, to the kind of paper or the desk they write on! They're crazy, etc.
The domestic	For me, there's an alliance between the Aesthetic (the Technical) and the Ethical; its privileged field: the minutiae of daily life, the "domestic." Perhaps wanting to write a novel (*the* Novel? *my* Novel?) is to enter into, to settle into a practice of *domestic* writing. Cf. Proust comparing the novel that's being written to a dress being cut, assembled, tacked together, in a word: *prepared* by a dressmaker (this is the sense in which 'the Preparation of the Novel' should be understood). In Proust's time – and the time of my childhood: dressmakers working from home, would go from house to house (Mademoiselle Sudour)[8] gleaning and relaying bits of news ⟶ dream of the Novelist's domestic labour: to be a Dressmaker working from home.

[5] Gustav Janouch, *Conversations with Kafka*, translated by Goronwy Rees, 2nd ed. (New York: New Directions, 1971), p.81.

[6] In French, Barthes writes 'métier', which can mean either 'profession' in the general sense of 'craft', 'aquired skill.' Since Barthes is talking explicitly about questions of technique and practice here, métier has been translated as 'craft.'

[7] In 1973, Jean-Louis Rambures interviewed a number of contemporary writers about their writing practice and published the series under the title *Comment travaillent les écrivains* (Paris, Flammarion, 1978). The text of his conversation with Barthes was first published in *Le Monde* on September 27, 1973. 'An Almost Obsessive Relation to Writing Instruments', in *The Grain of the Voice: Interviews 1962–1980*, trans. Linda Coverdale (Berkley: University of California Press, 1991); *OC* 4:p.483–7.

[8] Mademoiselle de Sudour was Barthes's grandmother's dressmaker in Bayonne

In 1975, Roland Barthes gave an interview entitled 'Literature/Teaching.'[1] When asked how 'pleasure' – specifically the pleasure of the text – might be integrated into the classroom, Barthes replied:

A priori, what would really be required would be to give children the opportunity to create complete objects (which a homework assignment cannot be), over an extended period of time. It would almost necessitate imagining that each pupil will write a book, and will set himself all the tasks necessary to its completion. It would be good to dwell on the idea of the model-object, or of production in a time prior to the reification of the product. In any case, it would be matter of bypassing the *given* of the exercise (assignment-composition) and offering the pupil a real opportunity to structure the different components of the object to be created. The pupil must come back, I won't say an individual, but a subject who manages his desire, his production, his creation.'[1]

In 1976, Barthes was appointed to a Chair of Literary Semiology at the Collège de France. Two years later in December 1978, following the sudden and painful event of his mother's death, under the sway of a new sense of urgency, a powerful desire for change, Barthes embarked on what would be his third and final lecture course: *The Preparation of the Novel*.[2] The exercise dreamt up for schoolchildren reads like a sketch of the one Barthes would eventually set himself: a singular pedagogical experiment that involved inviting students to imagine that he will be writing a book,

a literary work, for convenience called a novel. Before a packed auditorium, Barthes outlined the tasks that would be necessary to its completion, with a view to learning how to manage his desire, his production, his creation. The course – recast as a personal quest – ran for two years; the last lecture was delivered just a few weeks before the accident that led to Barthes' death in 1980.

Previous pages are an excerpt from my English translation of Barthes lecture and seminar notes for *The Preparation of the Novel 1 and 2*, to be published by Columbia University Press in autumn 2010. Here, three sessions in Part 1 of the lecture course (subtitled 'From Life to the Work'), we find Barthes clarifying the method adopted: not the *actual* writing of a novel, but the simulated *preparation* of / for a novel to come.

— Kate Briggs

[1] 'Literature / Teaching' in Roland Barthes, *The Grain of the Voice: Interviews 1962–1980*, trans. Linda Coverdale (Berkley and Los Angeles: University of California Press, 1991), p. 239 (translation modified).

[2] The three lecture courses were published in French by under the general editorship of Éric Marty. 1977: Roland Barthes, *Comment vivre ensemble: Simulations romanesques de quelques espaces quotidiens*, ed. Claude Coste (Paris: Seuil/IMEC, 2002); 1977–1978: *Le Neutre: Cours et séminaires au Collège de France 1977–1978*, ed. Thomas Clerc and Éric Marty (Paris: Seuil, 2002); 1978–1980: *La Préparation du roman I et II: Cours et séminaires au Collège de France*, ed. Nathalie Léger (Paris: Seuil, 2003). *The Neutral: Lecture Course at the Collège de France (1977–1978)*, translated by Rosalind E. Krauss and Denis Hollier, was published by Columbia University Press in 2005.

He had no arms and no legs.

He threw back his head and started to yell from fright. But he only started because he had no mouth to yell with. He was so surprised at not yelling when he tried that he began to work his jaws like a man who has found something interesting and wants to test it. He was so sure the idea of no mouth was a dream that he could investigate it calmly. He tried to work his jaws and he had no jaws. He tried to run his tongue around the inside of his teeth and over the roof of his mouth as if he were chasing a raspberry seed. But he didn't have any tongue and he hadn't any teeth. There was no roof to his mouth and there was no mouth. He tried to swallow but he couldn't because he had no palate and there weren't any muscles left to swallow with.

He began to smother and pant. It was as if someone had pushed a mattress over his face and was holding it there. He was breathing hard and fast now but he wasn't really breathing because there wasn't any air passing through his nose. He didn't have a nose. He could feel his chest rise and fall and quiver but not a breath of air was passing through the place where his nose used to be.

He got a wild panicky eagerness to die to kill

himself. He tried to calm his breathing to stop breathing entirely so he would suffocate. He could feel the muscles at the bottom of his throat close tight against the air but the breathing in his chest kept right on. There wasn't any air in his throat to be stopped. His lungs were sucking it in somewhere below his throat.

He knew now that he was surely dying but he was curious. He didn't want to die until he had found out everything. If a man has no nose and no mouth and no palate and no tongue why it stands to reason he might be shy a few other parts as well. But that was nonsense because a man in that shape would be dead. You couldn't lose that much of yourself and still keep on living. Yet if you knew you had lost them and were thinking about it why then you must be alive because dead men don't think. Dead men aren't curious and he was sick with curiosity so he must not be dead yet.

He began to reach out with the nerves of his face. He began to strain to feel the nothingness that was there. Where his mouth and nose had been there must now be nothing but a hole covered with bandages. He was trying to find out how far up that hole went. He was trying to feel the edges of the hole. He was grasping with the

,

,
,

, ,

,

, ,

, ,
,

nerves and pores of his face to follow the borders of that hole and see how far up they extended. It was like staring into complete darkness with your eyes popping out of your head. It was a process of feeling with his skin of exploring with something that couldn't move where his mind told it to. The nerves and muscles of his face were crawling like snakes toward his forehead.

The hole began at the base of his throat just below where his jaw should be and went upward in a widening circle. He could feel his skin creeping around the rim of the circle. The hole was getting bigger and bigger. It widened out almost to the base of his ears if he had any and then narrowed again. It ended somewhere above the top of what used to be his nose.

The hole went too high to have any eyes in it. He was blind.

It was funny how calm he was. He was quiet just like a storekeeper taking spring inventory and saying to himself I see I have no eyes better put that down in the order book. He had no legs and no arms and no eyes and no ears and no nose and no mouth and no tongue. What a hell of a dream. It must be a dream. Of course sweet god it's a dream. He'd have to wake up or he'd go nuts. Nobody could live like that. A person in

The seminal anti-war novel *Johnny Got His Gun* (1939) was authored by American screen writer Dalton Trumbo, who became one of the Hollywood Ten during the McCarthy era.

The entire novel was written without commas, though all other punctuation conforms to established conventions.

The term *comma* is derived from Greek komma, meaning 'something cut off.'

THERE ARE 36 WAYS TO VIEW MOUNT FUJI

HANNE LIPPARD

The 1st way is to use a ladder, and stare right into its side from the height you arrive at.

The 2nd way is to squint towards the sun and see it through your personal fog.

The 3rd way is to use a magnifying glass, not for viewing, but to burn a path in the grass when the sun shines through the glass, so that you can walk over and take a closer look.

The 4th way is to grow taller within short notice.

The 5th way is to sit in a cherry blossom tree, feeling the nature between your legs.

The 6th way is to always keep your window open because you never know when it will appear.

The 7th way is to see it together with someone, so that nobody can claim that you are lying.

The 8th way is to look at another mountain, saying Mount Fuji all the time until you are convinced about its true name.

The 9th way is to shout 'Wolf! Wolf!', because wolves are a common species in mountain territories.

The 10th way is to shout 'Black Bear!' instead of 'Wolf! Wolf!' because black bears have been seen in this area.

The 11th way is to not shout, but keep quiet because scientists are not sure if animals live on Mount Fuji.

The 12th way is to type Mount Fuji into Google and wait for what appears in front of you.

The 13th way is to see it at sunset and say 'What a beautiful sunset.'

The 14th way is to use the wing mirror on your car and drive around being able to see it from all sides.

The 15th way is to keep your head above water, even when tides are high.

The 16th way is to close your eyes, hold a rock in your left hand and then see what happens.

The 17th way is to listen to your mother, she was there in her youth and knows it better than you.

The 18th way is to see it at night and draw a spot on a piece of paper where you think that it is placed.

The 19th way is to keep this piece of paper, return in a year and see if you were right.

The 20th way is to become a scientist and look at it critically.

The 21st way is to become official and travel to see it on business without pleasure.

The 22nd way is to count to three.

The 23rd way is to count to ten.

The 24th way is to count to three times ten in another language.

The 25th way is to cut out a triangle from a cardboard box and place it in front of you at work.

The 26th way is to think outside this box.

The 27th way is to scrape your nails against its sides and take a look at what is now under your nails.

The 28th way is to burn your tongue and imagine Mount Fuji's eruption.

The 29th way is to stand on a stranger's shoulders to get a different view.

The 30th way is to stare at it until you get sick to death of it and hope to be buried at its foot.

The 31st way is to convince yourself of its existence in dull industrial areas.

The 32nd is to mirror its shape with the frame of your body.

The 33rd way is to develop a photograph that someone else took of it ten years ago.

The 34th way is to clear up the weather.

The 35th way is to look at its recent results.

The 36th way is to look at it as if this is your last sight.

There is however a last way to see Mount Fuji, and that is to hope that Fuji sees you first.

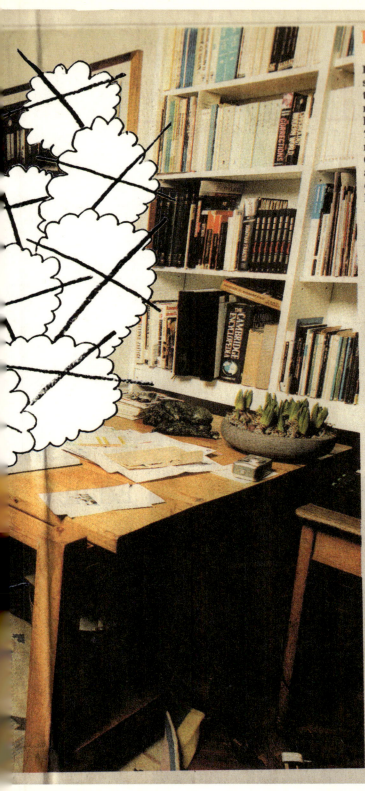

David Hare

I work in what was o
studio. It was origina
the furnace for a Vict
next door. Gertler liv
here from 1915 to 193
The Merry Go Round
now in the Tate – and
Carrington in the bed
above my head. Occa
odd art student come
knocks on the door.

The big pine desk
present from my futu
Jean Matheson, in 19
had just been produc
£50, and I've worked
The gifted designer
killed hang-gliding a

The problem for w
performing arts is th
place too easily beco
rather than a study.
administering plays,
them. So when I nee
hardest, I go away. I
ticular plays with th
significant parts of t
– *Plenty* and *Lickin*
ing shack in Brighto
ture in a cottage nea
Racing Demon in a h
tel during a very wet
Llandudno. *The Per*
about British rail pri
written beachside in
Afterwards, I like to
restaurants – that w
about the play all da

I write things out
then later put every
computer. The most
on my desk is a sma
by my wife Nicole Fa
sculpted just after w
her best pieces. Opp
wonderful photogra
of a production I di
Almeida of Shaw's
Emma Fielding is si
ing for Richard Griff
Wilton to come on a
For me, it expresses
tial. Looking at the
something good is a
And it did – every n

The Future's Getting Old Like The Rest Of Us

George Clark and Beatrice Gibson

'Scene Three, Memory' and 'Scene Four, Film' from the shooting script for *The Future's Getting Old Like The Rest Of Us*, a collaboration between Beatrice Gibson and George Clark.

Conceived in the format of a TV Play, and set in an old people's home, *The Future's Getting Old Like The Rest Of Us* is a 16mm film, part documentary and part fiction. The script for the film is constructed from verbatim transcripts of a discussion group held over a period of five months with the residents of an old people's home in Camden, London. Taking B.S. Johnson's 1971 experimental novel *House Mother Normal* as its formal departure point and employing the structural logic of a score, the script is edited into a vertical structure, in which eight voices or eight monologues occur simultaneously, offering eight different perspectives on a singular moment.

Retaining the developmental nature of the shooting script, errors have been left as they appeared.

Scene Three, Memory Scene Three, Memory Scene Three, Memory Scene Three, Memory

. oohh the arthritis .
. . . I can't clap my hands .

There is a lot of things that I could remember ... memory. . . memory to talk about it and sometimes it slips, you understand. Because it happens to you . Well according . . I don't have no special favourite memory anything like that but if I see something I memorize it....... yes yes yes if I go somewhere...... there is plenty places...... I could go and I went back there again and I could tell you directly I went there before because.... when I first came in the country I used to drive a train . . .

 . . .When Margaret Thatcher come and ... sign this ... Euston, Euston ... station ... It is I who went in Watford, drop her in Watford, took a train, it's not Watford . . . she was supposed to be . . . but I took her 1960 something 66 something like that... Yeah

My husband, he was a communist, historian of economics. But we've been through that. ..

 I was in the communist party he was in the young communist league. That's were we used to meet, how he met me. I never met him. He met me. He used to come to my office and put his feet on my desk, with his post office little cap on and then use to, there was a woman that was there and she liked me and she got very jealous of him coming along and taking me over, so she didn't like him very much wanted to get rid of him poor old Ron, mind you he did come in and lord himself about, have you met him?

 I never fell in love with my husband ever, I don't even now what falling in love means, I never really fell in love, I wouldn't really know if I have, its abstract, people say to me, do you remember your first sex with so and so. I might remember that. Just vaguely, you know, how can I put an answer to it. I can talk about men, males. They are all a bit boring. Not individually but I think that you except too much from them and you don't get it and you think what was all that about. Poor old Ronald. He was never a very exciting person. I never really had someone exciting to compare him with really. So I don't have anywhere to start if I can't compare him eh? I'm still hoping for an affair.

I came back to London. Silly boy. And the blitz began. I worked in all sorts of factories. In those days there was sort of um. . . cheap, er . . . most of the err. Skilled workers in London. Most of the older people have gone into the services. I was a boy. . . a tea boy....... or did some....... I used to go out and err and I must have been in half a dozen different jobs..... In the west end, little tiny jobs. I just remember the one name and it made some electrical goods and it went for war production. . . and I.no I never

 . . .I do remember.... remember the various.... most of these small places were private enterprise and they would come round ... I ... the old manager would come round. It was general practice. They would give you your money. Out in a tin. It was in a tin. . . I forget the amount.. I think it made up a pound. And there it was. And you would sign it. And then....

 . . . yes and, ... but then later on... fortunately, because it was a stupid life I was leading. . . After the war finished, and err I ... became ... I went into ... I discovered, ... I ... took evening classes at the working men's college in Crowndale Road.

Something happens and you say, oh that s what's so and so, don't you?

 . .And it's usually right in front of you. It's usually right near you. . . oh . . . oh . .

. . .Oh that's where I put it.

 . .
.Yes

 I told you I've done dancing. I have to not remember, not forget. I . . think that kept me in ... in . . .

hmmmm

 hahahaha
hmmmm

 Yes

hmmmmm

 . . . the m i n d is so funny

Scene Three, Memory | Scene Three, Memory | Scene Three, Memory | Scene Three, Memory

Memory? Memory remembers . . . stuck in your memory.

I think, I always think, when you you looking for, you put something somewhere and I'm sure I've put that there, you know, money I'm talking about, and you can't find it and then suddenly one day you might come across it, that's where it was all the time and there's not a happier feeling when you think its turned up for you after all that.

The day war, broke up, the kids, with their gas masks, I went away about that time, I remember crying. I went to a home and I remember the woman was called Charlotte, I went to Corby near North Hampton.

Yeah yeah you know you go and you say, this ain't new to me, I've been here before and you you, all day long where you've been, but you've haven't been there it's in the memory, and you still don't, probably you seen something of this place on the television and forgot all about it. .. I've been there.

Have you ever lost something for some time and you've thought to yourself I can't understand were that's gone and then you give up you think that gone and then one day you suddenly come across it and I think that's the best feeling you can have, you think oh that's where it was all the time

It's all very distant . . . incoherent now, but at the time it was real enough, and I, I remember, just one, one thing, a Mars bar, I think it was a Mars bar, we had pennies and pence In those days, at night ... I had a friend, we would smoke. It's all very, when was it, when the war broke out, I've learnt since it was the first of December with the double invasion of Poland, two polish ladies came to the home.

It's a wonderful feeling you've lost something you really treasure and you find it

Sometimes I put something where, I don't know where, and then I'll come back the next day and I've thought well I've put it somewhere and I've thought well... and the next day I've picked the thing up

My wife is in the Royal Free and it was the Royal Free, no, no, now she's at St. Margaret, the nursing home, she had um, what do they call it...?
De... de... dementia and sometimes I can walk in there and you'd wouldn't think there was a thing wrong with her, she's talking like, just like and then all of a sudden they say the next day oh she's run away again...
The reason why she runs away is because she done se.. see why she will ... she should, locked up for not doing anything, not commit a crime or anything. She sits there and cries.

They come and they go. Our memories. They're in the brain. That's the only place they can come from, the brain. They're things that I've acted. I feel them. Other people might remember the same thing as you're remembering. That's what I'm saying. Some subject, it's the other person leading up to a subject... the brain ... still ... too funny to . . . remember

I get mostly confused when I put something down and I can't remember where I put it. The next day you probably find it when you

Column 1

Here is a ya, that's er...

 Even though young men does the same thing just as you explain it. Men does the same thing. Two wives, real wives and they do a lot of things. . .

hmmm yes, Hmmmmmm
She is the woman yes

yes . . . what makes then do things yes

 yes I can

(Extract from 'Vertigo' plays, scene in gallery with Madeleine starring at portrait of Carlotta Valdes)

Oh hhhhhm

yes hmmmmmm
yeah hmmmmmm yeah

(Another extract plays, Judy remade as Madeleine, soundtrack plays, Scottie and Judy lingering embrace)

(Coughing)
 hmmmmmm

Hmmm yes yeah

Column 2

(Extract from 'Vertigo' plays, scene in gallery with Madeleine starring at portrait of Carlotta Valdes)

(Another extract plays, Judy remade as Madeleine, soundtrack plays, Scottie and Judy lingering embrace)

Column 3

I see, oh I see, yes, film, yes, Hitchcock, memory, he made so many didn't he.

I can't really think of names, there have been string of Italian directors. . . haven't there .

 Hitchcock

 Yes . . . too long

 Yes . .
I can see yes, thank you dear

(Extract from 'Vertigo' plays, scene in gallery with Madeleine starring at portrait of Carlotta Valdes)

Yeah hmm yeah.

Haircut? Coiffeur is what you mean, refined types.

(Another extract plays, Judy remade as Madeleine, soundtrack plays, Scottie and Judy lingering embrace)

You know Midsummer Nights Dream, or Love's Labours Lost, the yellow. . . um garters, stockings. oh but it was Malvolio, no ... but what I want to say ... in this type, in this....

Column 4

She could get a reflection from somewhere that looks like you.

A film, oh right yes . . . hmmmmm

Vertigo I see, that's right

 He was pretty brilliant wasn't he?

Yes yes, Psycho . . . the old woman, a double James Stewart, oh nice

*An idea of the plot, yes
 . . . into the present, yes*

 I don't want to be in . . . anyones way

 James Stewart . . . oohhh lovely

(Extract from 'Vertigo' plays, scene in gallery with Madeleine starring at portrait of Carlotta Valdes)

oooh ... look at the cars.

 *Into the other woman, I see yes ...
 ... Yeah hmm yeah*

(Another extract plays, Judy remade as Madeleine, soundtrack plays, Scottie and Judy lingering embrace)

. . . . She, she says I'm in it. I don't
 know. I haven't seen it, the film,
 I was in a film, you know, you
 know you used to come round
 every Wednesday.... My wife
 said she seen something with
 me in it...

 Has the film already been made?

ha ha ha

 He always appears in his own
 films though

. . . Sad really

 Jjjjames Stewart, James
 Stewart, yeah

he looks a bit worried there

(Extract from 'Vertigo' (Extract from 'Vertigo' (Extract from 'Vertigo' (Extract from 'Vertigo'
plays, scene in gallery plays, scene in gallery plays, scene in gallery plays, scene in gallery
with Madeleine starring at with Madeleine starring at with Madeleine starring at with Madeleine starring at
portrait of Carlotta Valdes) portrait of Carlotta Valdes) portrait of Carlotta Valdes) portrait of Carlotta Valdes)

(Another extract plays, (Another extract plays, (Another extract plays, (Another extract plays,
Judy remade as Madeleine, Judy remade as Madeleine, Judy remade as Madeleine, Judy remade as Madeleine,
soundtrack plays, Scottie soundtrack plays, Scottie soundtrack plays, Scottie soundtrack plays, Scottie
and Judy lingering embrace) and Judy lingering embrace) and Judy lingering embrace) and Judy lingering embrace)

So lovely ...

It's memories really isn't it
 Most people come to
some...

Why some people they call...... they have sex and having 7 and 8 and ten and 12 kids. You not supposed to have all these children. . . you see the trouble is you have to think about... if you die.... if you sick people going to take care of the children but not how you will take care of the children ... even you die. . . so not supposed to have all these children and all this

When you have so much children you think about those kids and then urr you go somewhere and...... you been able to have.... enjoy yourself, protect yourself and why 7, 8, 10, 12 children . . . I don't have 12 I haven't got 12 even if I had 12 children I ... I have 5 kids ... afterwards I say no I cant carry on with this... I tell you with woman its very very.... with woman when they have one kid, they have 2. They want to have 3. They want to have 4. They want to have 5. You have 7, 8, 9.

I see 20, 7, 27 . . . that's right listen let me tell you something. You can have it on your own but if the woman insists you should protect yourself, protect yourself, buy things and protect yourself ... you want to blame the woman but it's not really the woman you supposed to buy things and use and protect yourself and kind of yes yes ... protect the woman because I don't know woman having 7. She has 7, 8, 9, 12.. 14 that's too big 14.... you could be . . believe yourself . . but its not all there is plenty things beside making . . . too much children too much children

I have 5... not 5, 4 children ... 2 boys ... they are police Neville and Norman, you know. . .,They are police...

I'm still waiting for my dream world to come along. I do know males that I would like to know more, better, but I don't advertise that. . . I keep it to myself, don't mention it...

Sex is the overriding theme, especially from puberty. Or round that age ... I know, I, I, I was quite young when I was introduced to sex to sexual. . . and it still haunts me . . and it comes back and I suffer guilt and I .. I.. I ... read that the Gospel.... Purify the thoughts, the spirit, purify my spirit, oh lord. . . .

 ...you know drive the impure spirit out ... but you know ... the reality.... the brute ... I don't... when people come to puberty and middle age um ... its um ... you ... and it becomes ... I went on a binge you know over several years . .

I mean there are ... all sorts of schools of psychology aren't there. . . Freudians and so on. .

She was rather a sleepy dreamy sort of woman wasn't she

My frame . . .
 . . . frame . . .
 . . . poor old soul . . .

I can see my mum and dad,
they were very very in love
with each other, my mother,
she had seven children
but unfortunately she died
giving birth to the last child
and I was 9 years old when
she died, from then on life
seemed completely terrible.
. . . your father is at a loss,
the children are at loss.

 They really loved each
other. I can remember all
my uncles and aunts on a
Sunday would arrive up on
their motorbikes and side
cars and my mother would
have laid a lovely big table
for us to all to sit round.

I can see my mum and dad

Scene Four, Film	Scene Four, Film	Scene Four, Film	Scene Four, Film
	Are we going outside?	*The twilight zone?* *We're all au fait with it .* *Pirandello, yes.*	
			A ballerina
(Twilight Zone starts, .episode 'Five Characters In Search of an Exit')	(Twilight Zone starts, episode 'Five Characters In Search of an Exit')	(Twilight Zone starts, episode 'Five Characters In Search of an Exit')	(Twilight Zone starts, episode 'Five Characters In Search of an Exit')
	I need the toilet.	When the captain. . . err the general. . . says have you . . .tried banging on the wall,have you looked up here, . . .have you stamped your feetand all these various.... have you done everything to establish where we are? I take it they have done everything. . . have we exhausted every philosophical approach . . . have we had..... er..... what is man. . . have we exhausted the possibilities. . . I mean philosophers have been coming from the sun, in groups, as far as we know.... they've been going.... so there may be a.... I don't know..... have we exhausted....... there may be other thinkers, coming along in the future. er, something some sort of scientific. . . There is a group. There are people like.... Dawkins and so on . . who claim that the , er the universe . . . everything is explained through the scientific method, the scientific method. . . I'm not quite sure but everything according to common sense more or less.... way back in the middle ages it was Thomas Aquinas..... who proposed it. . . who cast it in question terms......of course I think, I . . I don't know . . .	
Hmhmhmmm			*Their in space are they, something similar to space, there going to take them into space are they?* They need to get out of there. (cough cough)
	Toilet, I need the toilet.		
		What would be the difference between......I know a person . . a Baron Münchausen person . . he's not restricted by..... a film as a matter of fact..... I sort . . I know . . somewhere with Margaret, with Susan . . I don't know where ... But anyway. . . um . . .	

Scene Four, Film | Scene Four, Film | Scene Four, Film | Scene Four, Film

Five characters in search of an exit? An exit?
Oh yes right about five characters. Oh right I see, a bagpipe player, I see ... Yeah ... And they're all trying to make their escape? Their escape? The zone, the twilight zone? Oh yes, the second one...

Do they all have different exits, and characters?
. . . *I see*

(Twilight Zone starts, episode 'Five Characters In Search of an Exit')

(Twilight Zone starts, episode 'Five Characters In Search of an Exit')

(Twilight Zone starts, episode 'Five Characters In Search of an Exit')

(Twilight Zone starts, episode 'Five Characters In Search of an Exit')

 I wish I could explain it. I would need to be a philosopher to explain, but a few words are always better than none, you've heard that, so I can only give my interpretation of it. . . I could be wrong. I could be right. if I'm wrong I could be corrected, is it, err ... the thing is there better be something in there, you know what I mean, like, from a biblical point of view, there better be something that. . . We can't just say we're going into space and we're going into fresh air, there must be something radically. . . something behind it all. I could be wrong by saying that, this is only what I'm saying, you know? I could be wrong, I could be right, I could be wrong. . . Well the main point is, it's very good, I enjoyed it, don't misunderstand me, it's a good thing, whether you're right or wrong to have a discussion, well I can only think along these lines. .
. . . surely there must be something, you can't just throw anybody into space, and everything like that, without something being there, truly there must be a God above ...

. . . . you don't believe in God? I'll leave it, maybe I've gone too far, I've been too extreme, nevertheless its interesting, and I agree with you, you know, I wouldn't be here otherwise ...
 . .. hahahahaha

. . oh Casablanca. They're showing Casablanca. And err it was a popular war time picture of... just after the war... yes thats right... and the famous song. A kiss. There s a chap in our unit, not only the Baron Münchausen, he's 95 . . . and he is telling them..... that he shouldered.... he was called up.... And he went to Mogadishu. There's a big island. Somewhere in the Indian ocean. Madagascar. John was saying today they shot....It was a Vichy French apparently, a Vichy French, he was shot by the British. Lined up and shot.

(Image of a cinema passed around) (Image of a cinema passed around) (Image of a cinema passed around) (Image of a cinema passed around)

We ll I have....I went to ... Something called. It was. I must have been... 14 or so... I saw John Wayne... and in er ...Stagecoach and the music. And the mountain and the background. And in the stage coach.... oh yes, in the stage coach. There were half a dozen people. A banker. And various characters. And John Wayne. It was dark. A desert storm blew up. And eventually the Indians came. From that great mountain. And Wayne and Claire Trevor. . . I never heard of her . . before . . she only made one or two. But John Wayne...... they were....... and it was very dark and . . . They were very quiet and you could see... The cigarette would be smoking... and Wayne evidently was trying to make contact with Trevor. . . . It was all very mysterious . . . because apparently they were outsiders . . and at the end Wayne comes to life. . . as it were . . . and he goes over to the man. . . in charge of the coach.... a fat man..... a fat man.... I remember the man in charge of the coach. With a beard. He was driving the coach. He was shot. Or something. . . and Wayne takes over.... and the horses brings them to a stand still.... The music

Cinema yes I remember

. . . . I was in Terry's Juveniles, a dancing troupe. . . . In between the pictures, I had a lovely time. Terry's Juveniles, we used to perform in the interval, I've got some photographs.

Why do you want to discuss about a cinema...... I'm 85,you think.... my grandson is bigger than him you know, two boys, Neville and Norman.... I'm talking about my grands.s.s.on.....we used to go there . . the cinema on holidays and Sundays.

... I was in Terry's Juveniles

I used to go to the cinema with my mother and sister, used to go every week, see all the old films, all the old film stars, and um, I used to love it, I didn't go much else apart from down in Kentish Town, there used to be...

 The different characters there's an element of unity and they are bonding together, there's a unity..

 Brothers and sisters never got on, they were always arguing with each other, there was no peace in it, so there a truth in what you're saying .

(Image of a cinema passed around) (Image of a cinema passed around) (Image of a cinema passed around) (Image of a cinema passed around)

 What's this?

 Leicester square , cinema . . . yes

 A cinema, oh yes

I read in the paper, comptometer operator needed for the BBC. And I'd not long been tested and I'd gone and learnt how to do this and I thought I'm going to apply for that and I feel now, computers, coming into this country now and of course its got bigger and bigger, this is arithmetic not letters

 The film, Stagecoach, it was the making of John Wayne as a cowboy and a hero, one of the best standing character actors was Andy Divine ... thanks to Andy Divine my wife can name every bump every horse that John Wayne went over, . . . he was brilliant, in this film he was going to shoot three brothers what killed his brother...

hhhmmm long time ago,

The one down in the square and it was quite cheap in the afternoon, all the kids used to go...

What about John Ford's other one... before that.. The Informer? His mother. And he is. What's that called..... Preston Forster was the IRA leader.... I don't know quite what caused it. And Charlie McGregor. He was Australian. And he played the part of the informer. He was the bully boy. His poor mother. An old woman then.... I mean it was... the informer..... and a feminine voice.... He also starred, he starred in... what was it . . .The chief. Hungary. I was surprised. He had a uniform, a very stiff uniform..... Marlene Dietrich was in it . .

... ooo .. that wasthat was . . .

My husband used to go more than me generally, but I did go once a week, once a week with my mum and sister, and see all the old . . Marlene Dietrich... my husband, my father was a film actor , we were in Sanders of The River with Paul Robeson, and I was in Men of Two Worlds with my father, I was on a set stripped down to the waist with jewellery all round me tits, I used to hate it, I use to hate having to strip down to the waist and have all this jewellery around me tits, I was about 18, so 60, 70 years ago . . well Men of Two Worlds, Sanders of The River, and Plant in The Sun, that was at the Unity Theatre, down Crowndale Road. . . it got bombed, or there was fire there . . . it got ruined anyway.

Great actor that, that Andy Divine, he seemed..... more than George . .

Yes Godard. Visconti. Bicycle Thieves, I saw them years ago. . . in Charring Cross, Charring Cross Road... I know.... there is a Greek theatre..... I used to go to evening classes at Crowndale road.... within spitting distance was a Greek theatre ... Around there anyway. Kings Cross...around Euston round.. . . er there was a place . .. The Regent Cinema where I saw lots of films...

The only Marx Brothers I can remember,and while I'm about it.....I couldn't think of the regal lady. Her name was Marguerite Dumont. She had the, she had the, pince-nez. She was. . . err, Groucho. He was always in hot pursuit of her.

John Wayne its yesterday, John Wayne is yesterday. Why you talking if I want to play somebody.... John Wayne is yesterday. . I don't recognise the person that I want to play.

My father's, my father, he used to drink rum, that was his drink, his drink was rum, rum and women.
 . . . One woman was getting her.... and the husband came over to protect her and they shot him and he said I've been shot. . . and he died there, I was 30.

Pistachio please.

Orsen Welles, he was so..... I never.... Orsen Welles. The films made in Spain. Chimes of Midnight, s..s..s.so so..... The Tudors and um, Mary Tudor. She was the daughter of Catherine of Aragon . . .

Ice cream, I don't want ice cream, I too big already.

Strawberry please,

Now you come up here, you don't know nothing, don't know nothing.... you ever seen grapefruit? When you cut it and you take of the heart and you peel and you cook that grapefruit with fish, .. oh hmmmmmmm.

I want to get up and sit in that chair.

It's not an easy decision is it, you're talking about John Wayne, you're talking about Andy Divine . . . when you're speaking about Andy Divine your talking about an advanced man, he became more supreme than John Wayne.

I think something that came across too, with the characters, they were all very very different but they appeared to have the same stress and the same needs, . . . the clown the whole lot.

Ice cream? Chocolate

I was a nun for seventeen years, I was on television, they needed a nun, I was 21. It was the ceremony, the church was in Scotland, the convent was there, it was a beautiful island, and the bishop he was thirsty and he picked the flowers out of this vase and the water was yellow, but he drank it. Love is my falling down. They were very liberal at that time, I became engaged to a doctor, and they allowed me to write to him and he said, you can choose, he said choose me though or I'll be sad every day of my life.

Rum and raisin, please

EDUCATION FOR EMANCIPATION

RUTH EWAN

'I can promise to be candid but not impartial.'
– The Plebs' League motto.

In 1908 a group of working-class students at Ruskin College, Oxford went on strike, claiming that they 'found the specious lies of the professors in contrast to their workaday experiences; how impossible to them seemed the mutual understanding between employer and employee there advocated'. This marked the formation of The Plebs' League, a progressive educational association which attempted to create a new learning system, free from capitalist and imperialist ideology and funded exclusively by workers' organisations including, the South Wales Miners' Federation and the National Union of Railwaymen.

Issue 1 of *The Plebs* (the Leagues' magazine which ran in various guises from 1908 to 1970) set out their agenda, the crux of which was 'to permeate the Labour Movement in all its ramifications with the desire for human liberation'.

As well as publishing a monthly magazine, textbooks and atlases, the League organised classes across the UK; taking particular hold in South Wales, the North East, Lancashire and Scotland. Through the establishment of the National Council of Labour Colleges by the late 1920s there were 1,201 regular Plebs' classes across Britain, with nearly 32,000 members taking part in a nationwide network of participatory based learning ranging across: reading lists; discussions; lantern lectures and pleasure trips. Attracting a range of students from Trade Unions, Labour and Co-operative groups, members joined with the aim of gaining a deeper knowledge and understanding of international political and social affairs. Notable individuals involved in the movement include the political cartographer and cartoonist J.F. Horrabin, his wife the suffragette and journalist Winifred Horrabin, trade unionist and MP Ebby Edwards, Scottish activist John MacLean and historian and gourmet, Raymond Postgate.

I first picked up a copy of *The Plebs* in 2006 on a visit to the Working Class Movement Library in Salford. Attracted to the early editions by the charmingly pointed illustrations of J.F. Horrabin, I was intrigued by the insight the magazines offered into an energised organisation, craving a post-capitalist world that could be united through the 'culturally neutral' language of Esperanto. This issue of *The Happy Hypocrite* reprints selected articles from *The Plebs*, with particular focus on the idea of independent education, an idea still pertinent today. Accompanying this reprint sits a selection of related drawings made in collaboration with young people who I have invited to reinterpret, copy or deface found images.

GET OFF YOUR KNEES!

Sept. 1932

fourpence

THE PLEBS

Organ of the National Council of Labour Colleges ::

It's a Nice Horse—but it's not going anywhere.

See leading Article.

DO YOU COUNT?

In the struggle for working-class emancipation, the hub round which current history revolves, *do you count*? Just as the individual, himself weak, adds mightily to his strength by co-operating with his fellows, so can he, with his very limited experience add tremendously to his mental power by drawing on the knowledge of his fellows—by educating himself!

In nearly all important centres there are National Council of Labour Colleges classes —join them!

If you want to study at leisure take up a Correspondence Course on English Grammar and Essay Writing, Industrial History, Economics, Economic Geography and Public Speaking.

Has your Union an Educational Scheme with the N.C.L.C. providing free evening classes and correspondence courses for the members? If not, get busy! What the A.U.B.T.W., N.U.D.A.W., A.E.U., Sheet Metal Workers and other Unions can do, can be done by yours!

NATIONAL COUNCIL OF LABOUR COLLEGES
22 ELM ROW, EDINBURGH

struggles; she regarded all nationalist struggles as an anachronism; she believed all the talk about self-determination of the nations was rather retrogressive, and that it was particularly dangerous for the proletarian revolution to get involved in nationalist conflicts.

Lenin opposed her, being convinced that the struggle for national emancipation, particularly in Asia, would play an important rôle in the universal socal revolution. Reviewing a pamphlet written by Luxemburg in 1916 and published in 1916 under the pseudonym of "Junius" (*Krise der Sozialdemokratie*), Lenin declared: "Nationalist wars against Imperialism are not only possible and probable, but inevitable, and must be regarded as progressive and revolutionary. For instance, a national war of liberation by Persia, India, and China is quite probable, and will be of great assistance to a proletarian revolution in any of the great countries of Europe. Under a Socialist régime the right of nationalities to self-determination must be recognised." (Written by Lenin in the autumn, 1916).

<div style="text-align:right">M. BEER.</div>

CAPITALISM AND EDUCATION

THE most important question that confronts the Labour Movement is, in my opinion, the question of education. If it be true—as it undoubtedly is—that the majority of the evils which afflict society to-day are the product of the capitalist system of society, and would cease to exist with the passing of that system, it is equally true that Capitalism persists only because of the ignorance of the masses of the workers, who hold in their hands the means to destroy it, or, as I would prefer to phrase it, to resolve the antinomy of the class struggle into the higher unity of the Socialist Commonwealth.

A good deal of the propaganda engaged in by the various sections of our movement is not propaganda in the real sense of the word at all, but is a genuine effort to instruct adult minds in some of the elementary facts and principles of economics and sociology. In a more obvious manner the National Council of Labour Colleges is engaged in the same task. I take the difference between education and propaganda to be that, whilst the educator endeavours to lead minds to the observation and discovery of facts and to the drawing of valid conclusions therefrom, the propagandist's aim is to influence minds to accept opinions by any means at his disposal. The distinction is a real one; but it is not hard and fast, for the world of experience does not permit of hard and fast distinctions being drawn. It may be asked, for example, whether it is not certain that some-

thing of the educator's personality—his views and opinions—must, even if he be most experienced in impartiality, be transmitted to the minds he educates. On the other hand, whilst propaganda may descend to mere vote-catching in the realm of politics, or to the hypnotic artifice of the mass suggestion that compels us (if we do not resist its effects) to buy so-and-so's cocoa and so-and-so's pills, because so-and-so's name is shouted at us from every hoarding and newspaper, it may, as I have already pointed out, contain a large proportion of strictly educative material.

The educative side of the work of the Labour movement is, to my mind, of paramount importance, and, indeed, I like to envisage the movement as essentially an educative one. If it is true, as I am convinced, that an impartial examination of the facts of history and of the structure of present-day society clearly demonstrates the existence of the class struggle, it would seem that the mere presentation of these facts to the mind of the worker should result in his immediate adherence to Socialism. Actually, however, a resistance to the inevitable conclusion is too frequently met with, a resistance arising, in some cases, from a contrary opinion based upon partial and inaccurate information, in some cases from sheer prejudice.

What, let us ask, is the source of this resistance? And let us, in the first place, approach the solution to this question *a priori*. Capitalist governments can only hope to remain in power in a democratic country in virtue of the ignorance of the workers. Is it not obvious, therefore, that in the schools controlled by such Governments every effort possible will be made to achieve this end? An examination of the education of the young worker in the State-controlled schools is indicated as providing a solution to the question of why democracy has failed.

We have, when we come to examine the facts, the classic instance of imperialist Russia, which kept its people in the darkest ignorance; an enquiry undertaken in 1920 revealing the terrible fact that six out of every ten Russians over the age of eight were illiterate. In this country free elementary education was most grudgingly granted to the workers; and the present Government's attitude towards education in this country, as that of its predecessors (with the single exception of the short-lived Labour Government), can be summed up in the one word "Economy."

It is not, however, merely the question of the *quantity* of education provided by the State schools with which we are concerned. We have also to consider the question of its *quality*. Here, also, the cloven hoof of capitalism is only too clearly manifest. The free education to be given in the elementary schools was originally defined as that "suited to the conditions of workmen and servants," *i.e.*, its object was to produce docile wage slaves, and the influence of the old prescription has by no means passed away. The Teachers'

SUBSCRIBE

— *The Happy Hypocrite*

Subscribe to issues 6 and 7 of The Happy Hypocrite at the special price of £18.00 including postage for both issues.

Issue 5: What Am I?
Roland Barthes? *As if.* Explicit revelations of privacy, non-introspective personae, shifting polymorphous presence, Plebs, mirror gazing, mistranslations and proof-marks, composite semaphore, and Mount Fuji. I am what? Contributors include: Roland Barthes, Shumon Basar, Kate Briggs, George Clark and Beatrice Gibson, Ruth Ewan, Antonia Hirsch, Chris Kraus, Hanne Lippard, Seth Price, Laure Prouvost, Stephen Sutcliffe and Sarah Tripp. Spring/Summer 2010

Issue 6:
Autumn/Winter 2010

Issue 7:
Spring/Summer 2011

Back issues available from www.bookworks.org.uk

For payment by credit card we need the following information:

Card Type
☐ M/C ☐ Visa ☐ Switch ☐ Visa Debit
Card Number _____
Name on Card _____
Billing Address (including full postcode)

Delivery Address (if different from above)

Contact Telephone Number _____
Expiry Date _____
Start Date _____

Issue Number (Switch only) _____
Security Code (3 digits) _____

Post to:
Subscriptions at The Happy Hypocrite
Book Works, 19 Holywell Row, London EC2A 4JB
Fax to:
+44 (0) 20 7247 2540

Alternatively, please make cheques (£ sterling only) payable to 'Book Works (UK) Ltd' and post to the above address.

For further information please email:
james@bookworks.org.uk

Labour League has been criticised for advocating political propaganda in the schools. This it has never done. What it has done is to call attention to the political propaganda already existent in the schools. For this it has, very naturally, incurred the high displeasure of Lord Eustace Percy. I say "only naturally," for Lord Percy is sagacious enough to know that, were it not for the continual poisoning of the minds of the workers' children in the State schools, the capitalist system would inevitably come to an end. The propaganda is particularly carried on by means of history books which deal only with the doings of kings and their governments, and ignore the life of common people, dismissing the aspirations of the workers with contempt, by the utilisation of Empire Day and similar occasions to inoculate the minds of the workers' children with the poisonous germs of Tory imperialism, as well as in other ways.

Against this gross misuse of the State schools, which is an inevitable phenomenon of capitalism, the Labour Party at the instance of the Teachers' Labour League unanimously passed, at its last Annual Conference, a strong resolution of protest, and called upon Labour members of educational authorities and Labour school managers to take steps to prevent its continuance.

The question of the education of the worker's child is a question of vital importance to the whole Labour movement. On the right solution of the many problems involved, the future welfare of the world may well depend. The League is engaged in the task of studying these problems. In particular, its last Annual Conference instructed it to investigate the whole problem of "class bias" in education. The bitter attacks which have been made on the League in the capitalist Press undoubtedly spring from fear as to what the report of this investigation may reveal as to the anti-working-class bias of the education meted out to the children of the workers in so many schools to-day.

We are confronted by the tragedy of ignorance. Our task is the creation of an educated democracy. It is the task of the whole Labour movement, a task in the achievement of which the Teachers' Labour League, on the one hand, and the National Council of Labour Colleges, on the other hand, have special parts to play. Forward, comrades!

H. STANLEY REDGROVE, B.Sc.
(President of the Teachers' Labour League).

WE DON'T CHARGE YOU INTEREST—
BUT OUR BANKERS CHARGE US, WHEN WE ARE ON OVERDRAFT BECAUSE
YOU HAVEN'T PAID YOUR BILL!
HAVE You Paid Your Bill to the Office?

before that problem has been faced is useless. Second, the importance of the workers abandoning the isolation which confines their attention to purely industrial questions, and reaching out to secure the co-operation of the peasant food producers. Third, that at the acute stage of the class struggle it is not a question of "spontaneity" —that leads only to riots without conscious purpose—it is not merely a question of machinery—that can be used for wrong purposes— but it is a question of a disciplined, organised and courageous lead being given to the masses. And this lead must be a *political* lead— it must focus their struggle and their attention on the problem of the capitalist State and the problem of supplanting it by a workers' seizure of power. The machinery may be perfect, the masses may be educated and class-conscious, and economic conditions may be "riper" than ever before or ever again, yet if faith in a leadership which will lead only "up the garden" continues, the whole movement will break down as dismally as in Vienna both in 1920 and in 1927. ZED.

A WORD FOR ESPERANTO

The Professor of German and Honorary Lecturer in Comparative Philology in the University of Liverpool here replies to Raymond Postgate's strictures on Esperanto in our last issue.

IT is a pity that a man of Mr. Postgate's standing in the Labour world should feel moved to "crab" Esperanto, for though Esperanto may not be theoretically perfect, yet it is adequate to all the practical international tasks imposed upon it, and is the sole international language in common world-wide use to any great extent. Still, he has raised certain specific points, and I should like to ask him to consider on hearing the evidence whether some of the alleged "defects" are not really positive merits. And there is abundant literature on the subject, if he seriously desires to go into the question.

After all, the language must be treated as a whole, and not have elements drawn out here and there. If, at the worst, there appear to remain one or two "defects" of a more serious character, these will in course of time be remedied by the Linguistic Committees, which at present naturally err, if at all, on the conservative side.

No Esperantists argue in the way imputed to them in Mr. Postgate's second paragraph. What they do say is that the workers need an international language, easy to learn and handle, developed by actual use, and sufficiently propagated to be immediately useful. So far, the only language to fulfil these conditions adequately is Esperanto.

Unlike Volapük, Esperanto is not stereotyped beyond the reach of change and improvement. But in the initial stage, until it is firmly established, Esperantists believe that adherence to a ground-plan will ensure continuity of development and preclude dialect formation. Volapükists split their movement by evolving completely new schemes, and wasted their strength in internal conflict. Esperanto has made headway in spite of the handicap of the failure of Volapük. To scrap Esperanto would produce such disillusionment in the minds of the public that the whole International Language movement would have a set-back from which it would be difficult to recover. I once heard Volapük spoken by two Germans who had gone over to Esperanto, and not a word was recognised. Whereas I find that audiences can often make out the gist of a sentence pronounced to them in Esperanto without any previous knowledge of the language at all.

As to the alphabet, I grant that Esperanto contains some combinations of letters not common in English (e.g., *sc* in *scienco,* with the purpose of maintaining the international form of the word; or *kv,* which agrees with the normal German pronunciation of *qu-,* e.g., *kvalito*). It may, however, be indicated that these are but a few small points, the removal of which would involve greater disadvantages, e.g., the substitution of unsatisfactory forms like *sienco* or *cienco,* or the insertion into the alphabet of the redundant *q*. In any case, possible small deviations of pronunciation, like *s* for *sc,* do not interfere with understanding, and it is significant that some Idists are now advocating a return to *scienco*! When English children of four or five pronounce Esperanto with ease, is it worth while, in a discussion supposedly serious, to talk of horrible noises unpronounceable without injury to the jaw? This might surely be left to the comic press.

The six accented letters of Esperanto may be compared with thirteen such in French, nineteen in Lithuanian, seven in Spanish, etc. Do we, then, "have to smash up our typewriters and alter our printing machines" to print French, which has more than twice as many accented letters as Esperanto? Did the compositor of PLEBS alter his machine to use his excellent Esperanto type in two founts when setting up Mr. Postgate's article?

Mr. Postgate is apparently unaware that Esperanto may easily be printed on both the monotype and the linotype. As early as 1908 the Monotype Co. gave a quotation of 2/6 per matrix for the Esperanto type, and of 27/- for the set of twelve accented letters (including caps.), from which an unlimited supply of "'movable" can be obtained. The Esperanto newspaper *Heroldo* is printed on a linotype machine. If the Esperanto accented type, although perhaps theoretically the best solution of the problem of a phonetic

alphabet, nevertheless presents such formidable difficulties in practice, how is it that printers throughout the world are producing an ever-increasing flow of literature of all kinds, and that Esperanto, which alone of international languages uses these letters, is the only one to achieve this practical success? The "naïve Esperantist reviewer" was not ignorant of these facts.

The example chosen to demonstrate the Esperanto system of derivation as being *à priori* is not quite happy, for *bo-* is the phonetic form of French "beau" in *beau-pere,* and, as a matter of fact, relationship by marriage is indicated in most European languages as in Esperanto, by a compound in which the first component denotes this specific form of relationship, e.g., Germ. *Schwieger-,* Dutch *Schoon-* (translation of *beau-*), etc.

I suppose many languages could, if they wanted, form long compounds of the type Mr. Postgate invents to ridicule. The question is simply that of the extent to which a given writer or speaker cares to use this liberty. When writing on technical matters one finds it most useful to be able, as in Esperanto, to improvise new compounds and derivatives beyond the fixed vocabulary of Latin.

The few Slavic and the rather more numerous German roots have been adopted by Esperanto not out of an irrational sentimentality, but either (1) because of their greater suitability in practice, e.g., the word for "and," where the possible use of *et* or *e(d)* would involve practical difficulties, and where the Esperanto *kaj* was justified by Zamenhof as early as 1891, or (2) to avoid certain ambiguities, as when *varma* is chosen in preference to *kalda,* lest the Romance peoples take the latter in the sense of *"warm"* when a German or Englishman might take it for *cold;* and *ŝafo* (German) for "sheep," because a root from the Latin *ovis* might be confused with *ovo* "egg." *Klein-* does not exist in Esperanto, and if it did, why should it mean "famous"? The Russian *cherpat,* giving the root *cherp-* is short and—though not related—does suggest the German *schöpfen* (and cognate forms in the other Germanic languages).

In criticising the grammar of Esperanto, Mr. Postgate forgets that the tense-system of the verb, when once learnt—and experience in teaching it proves how easily it may be acquired !—stands good for all verbs. If he had had to teach foreigners the subtle differences between *shall* and *will,* he would appreciate the simple Esperanto form in *-os,* always used for the future and for nothing else.

It matters little whether you insert a whole word, or suffix a syllable, *provided that the application is made without exception.* It would be just as easy to learn, say, the Finnish ending *-sta* for "out of" in *kirko-sta* (out of church), *Liverpoolista,* "out of Liverpool," etc., as to learn the words "out of." We have to be able

to express (a) present, (b) future, and (c) past tense, (d) conditions, and (e) wishes *somehow*. And to learn once and for all that these are expressed by adding to the root (a) *-as,* (b) *-os,* (c) *-is,* (d) *-us,* (e) *-u* rsepectively, does not seem to be any more difficult than to have to learn, e.g., separate particles like the Interlingua *i* for the future and *e* for the past. The participial tenses, while adding precision to Esperanto, may cause some difficulty to learners; it must, however, be pointed out that these expanded constructions are not often used, and their possibility offers considerable practical advantages.

I candidly admit that the alphabet of Esperanto does give it at first sight a rather strange look to English eyes, but familiarity soon makes it appear perfectly normal and undisturbing. Also there are bound to be details (*mal-* is one) which may not meet with the approval of all. But the essential point is that Esperanto is in actual use to a very great extent in varied fields, and all who have written letters in it, or—as I have—spoken in it to international audiences, e.g., at Geneva in 1922 and Edinburgh in 1926, know that it is already a medium of great practical utility. It seems wise —even if we may not think it theoretically perfect in all details—to accept it as a working basis, and see to it that it is gradually developed in accordance with international desires. The point is that it is already very useful now. I could hope that Mr. Postgate would lay aside any initial misgivings, and after a week or two's study (which would suffice a man of his linguistic equipment) write a letter in Esperanto to some foreign correspondent interested in his particular subjects—or, better still, attend some international Esperanto Congress, and see how neatly and thoroughly the business is there transacted. I assure him that I have no prejudice against *Interlingua* as such—it is a very skilful adaptation of Latin— but when I see the manner in which Esperanto appeals to the Central and Eastern Europeans and to the Oriental peoples, I should feel very reluctant to abandon it in favour of a new scheme on a purely Western European basis. In Lancashire I have met many workers who had previously learnt no language except English, but who transact business in Esperanto. So far I have never heard of any single person using Interlingua who had not a prior knowledge of Latin, and I fail to see how any purely theoretical argument can carry conviction to those who have had personal experience of the value of Esperanto.

<div style="text-align:right">W. E. COLLINSON.</div>

ENERGY

ENERGY is good; energy needs direction; but, much more than that, energy needs the *right* direction.

Labour is gaining power; but power is wasted, because some Workers, who oppose the Governing Class industrially and politically, make the *fundamental mistake of co-operating with them educationally.*

Before deciding that any Educational Body is to be entrusted with Trade Union education, ask whether it receives heavy subsidies from the Capitalist State.

Consistent Trade Unionists demand *Independent* Working-Class Education (which arose out of a strike of students at Ruskin College against its University type of teaching). This Independent Education is provided by

THE NATIONAL COUNCIL OF LABOUR COLLEGES

The N.C.L.C. operates the bulk of British Trade Union Educational Schemes, and provides Evening Classes, Week-end and Summer Schools, Residential Tuition, Correspondence Courses, etc. It has more Trade Union Correspondence Students than any other Working-class Educational Organisation in the World.

Send threepence in stamps for 24-page Booklet on "The N.C.L.C. and Its Work," to J. P. M. Millar, General Secretary, N.C.L.C., 62, Hanover St., Edinburgh.

SIX SOUND REASONS

for buying all your Books and Periodicals at

LABOUR'S BEST BOOKSELLERS

1. The Communist Bookshop is the largest literature agency in the Labour movement.
2. Its staff is therefore widely experienced and highly trained, and can give expert and intelligent advice on the choice of books.
3. Its premises are centrally situated in London if you want to call.
4. It has an unrivalled reputation for handling mail orders quickly and efficiently.
5. It deals in literature on *all* topics— Labour, educational, scientific, and even fiction!
6. Its Catalogue (post free on application) is arranged on a subject basis and is a valuable guide for worker-students.

THE COMMUNIST BOOKSHOP
16 KING STREET, COVENT GARDEN, W.C.2

READ MORE —— KNOW MORE

The New Student should purchase *What to Read*, 3d post free, and *Why, How and What to Read*, 3d post free. These two pamphlets are excellent reading guides for the beginner

English, Public Speaking, etc.

	Price	Post free
English Etymology (MacDougal)	2/-	2/3
English Grammar & Analysis (Dunlop)	2/-	2/-
English for Home Students (Adkins)	1/-	1/2
The Labour Chairman (Citrine)	2/6	2/9
Chambers' Twentieth Century Dictionary (Over 1200 pages)	7/6	8/3
Art of Lecturing (Lewis)	2/6	2/9

English History, Government, Trade Unionism, etc.

	Price	Post free
Trade Union Movement in Great Britain (Citrine)	2/-	2/-
Local Government of United Kingdom and Irish Free State (Clarke)	5/-	5/6
Outlines of Central Government (Clarke)	5/-	5/6
English Economic History (Cole)	6d	7d
British Trades Unionism—Policy (Cole)	6d	7d
History of British Socialism (Beer) (2 vols.)	15/-	15/9
How the Ratepayer is Governed (K. Rosenburg)	3/6	3/8
Pocket Book for County Councillors (Herbert Dunnico, M.P.)	6d	7d
Local Government Speakers' Handbook (Labour Party)	6d	7d
Chartism and Trade Unionism (Postgate)	6d	7d
Labour Year Book		3/S
Cloth		5/-

History, Geography, etc.

	Price	Post free
Outline of History (Wells) (With Illustrations by J. F. H.)	8/6	9/3
Geography and World Power (Fairgrieve)	5/-	5/6
Phillips' School Atlas of Commercial Geography	2/-	2/4
Phillips' School Atlas of Comparative Geography	3/6	3/10
Evolution of Property (Paul Lafargue) Limp Cloth	2/6	2/8
Cloth	3/6	3/9
Short History of the World (Wells)	1/-	1/3
The Paris Commune (Siegel)	8d	9d
The Paris Commune (Little Lenin Library)	1/-	1/2

Socialism, Marxism, etc.

	Price	Post free
Marxism (Beer)	6d	7d
Communist Manifesto (Marx & Engels) (Edited by Ryazanoff)	6/-	6/6
Fundamental Problems of Marxism (Ryazanoff)	5/-	5/6
Socialism, Utopian and Scientific (Engels)	3d	4d
Life and Teaching of Marx (M. Beer)	3/6	3/8
Intelligent Woman's Guide to Socialism (Bernard Shaw)	5/-	5/6
Karl Marx and F. Engels (Ryazanoff)	6/-	6/6
What is to be Done (Lenin)	2/-	2/3

Russia—a Selection of Novels.

	Price	Post free
Red Cavalry (Babel)	3/6	3/9
Tashkent (Neverov)	6/-	6/3
The Man Who Was Afraid (Gorki)	3/6	3/8
Mother (Gorki)	5/-	5/5

Russia—a Selection of Other Books.

	Price	Post free
The Five-Year Plan (Grinko)	5/-	5/5
Red Villages (Yakovleo)	2/-	2/3
Building Collective Farms (Stalin)	2/6	2/8
On Lenin (Gorki)	6d	8d
Lenin (Mirsky)	5/-	5/3
Russia (Mirsky)	25/-	25/9
Science in the Soviet Union (Crowther)	7/6	7/10
Russian Economic Development since the Revolution (Dobb)	3/6	3/10
Russia's Productive System (E. Burns)	12/6	13/-
Russia To-Day and To-Morrow (Dobb)	1/6	1/7

Novels for Plebeians.

	Price	Post free
Ragged-Trousered Philanthropist (Tresall)	2/-	2/3
News from Nowhere (Morris)	1/6	1/8
A Dream of John Ball (Morris)	1/6	1/8
Looking Backward (Bellamy)	1/6	1/8
All Quiet on the Western Front	3/6	3/10
Hunger and Love (Britton)	7/6	8/-
The Gate of a Strange Field (Heslop)	3/6	4/-
Drifting Men (Fox)	6/-	6/4

WAR AGAINST WAR — 1/- 1/2
(Actual Photographs taken on all Fronts).

The PLEBS LEAGUE

CONSTITUTION

Object.—The general aim of the Plebs League is :—To develop and increase the class-consciousness of the workers, by propaganda and education, in order to aid them to destroy wage-slavery and to win power.

Methods.—The means used for this end are :—

1. The support of the National Council of Labour Colleges and the classes run under its auspices.

2. The maintenance of the class-conscious character of the teaching in the present organs and institutions of independent working-class education.

3. The publication of a Magazine and, in concert with the N.C.L.C., of text-books, syllabuses and other publications.

4. The holding of summer schools, teachers' conferences, etc.

5. Propaganda among workers' organisations for the adoption of new schemes of independent working-class education or the extension of existing schemes.

The League is intended to link together members of the Labour Movement for the discussion and advancement of a revolutionary industrial and political movement suited to British conditions.

Every supporter of independent working-class education —"Education towards Revolution," in Morris's phrase—should join the Plebs League. The League is the link between tutors, organisers, officials, class-students, and every worker in our movement.

Minimum Subscription, 1/- per annum

Badges (brooch or stud), 1/- each

PLEBS, 162a Buckingham Palace Road, London, S.W.1

PLEBS

SEPTEMBER 1927 FOURPENCE

— Contributors —

Shumon Basar
is a writer, editor, curator and director of the Cultural Programme at the Architectural Association in London. He co-founded the print-event collective sexymachinery, and is contributing editor at *Bidoun* and *Tank* magazines. His co-edited books include: *Did Someone Say Participate?*; *Cities from Zero*; *With/Without*; *The World of Madelon Vriesendorp* and the forthcoming *Hans Ulrich Obrist Interviews Volume 2*. He is currently working on a film script with Jane and Louise Wilson and Eyal Weizman as well as writing a novel set in the Gulf region, entitled *World World World!*

Kate Briggs
is a writer and translator based in Paris. Current projects include: a translation of Roland Barthes's *Comment vivre ensemble* for Columbia University Press; *How to Write: Entertaining Ideas*: a book project which documents and tests actual and hypothetical writing practices from the nineteenth century to the present; *Exercise in Pathetic Criticism*, a reconstruction of Alexandre Dumas' *The Count of Monte Cristo* and *Instructions for a Writing Class*: an experimental syllabus (in the form of a postal project) devised in collaboration with Chloe Briggs.

George Clark
is a curator, writer and artist based in London. He was the Artists' Moving Image Development Officer at the Independent Cinema Office (2006–08) and has initiated a number of independent curatorial projects. His writings have been published in magazines including: *Art Monthly*; *Afterall*; *Sight & Sound*; *Senses of Cinema* and *Vertigo*.

Ruth Ewan
is a Scottish artist based in London. Her work has been shown as part of Art Sheffield (2010); Frieze Projects (2009); *Altermodern: Tate Triennial* (2009) and *Younger Than Jesus*, New Spain Museum, New York (2009). Recent solo exhibitions include *El nuestro es el mundo a pesar de todos*, Kiosko Galeria, Santa Cruz de la Sierra, Bolivia; *A Jukebox of People Trying to Change the World*, Ancient & Modern, London; *Fang Sang*, ICA, London and *Did You Kiss the Foot that Kicked You?*, Artangel, London.

Maria Fusco
is a Belfast-born writer based in London. She is founder/editor of *The Happy Hypocrite* and Director of Art Writing at Goldsmiths, University of London. She was the inaugural Writer in Residence at Whitechapel Gallery in London (2009–10) and the inaugural Critic in Residence at The Kadist Art Foundation in Paris (2008–09). *The Mechanical Copula*, a book of her short stories will be published by Sternberg Press later this year.

Beatrice Gibson
is an artist based in London. Manifest largely as text, performance and film, her practice explores ideas around sound, sociality, models of collective production and the problems of representation. She is currently working on a new film commission from the Serpentine Gallery, London with George Clark.

Antonia Hirsch
is an artist who lives and works in Berlin and Vancouver. Her practice engages with systems – geographical, quantitative, syntactic – that underwrite the most basic understandings of the world. She questions the often invisible hierarchies of these epistemological structures by relating them to more familiar territory: embodied experience. Her work has been exhibited at Program, Berlin; Taipei Fine Arts Museum; Power Plant, Toronto and Vancouver Art Gallery, among others. Her book-length artist's publication based on Dalton Trumbo's novel *Johnny Got His Gun* is forthcoming from Fillip Editions and a related film installation will be presented at Frieze Projects later this year.

Chris Kraus
is the author of four novels, including *I Love Dick*; *Torpor* and the forthcoming *Summer of Hate* (2010). She also writes about art, and is an editor at Semiotext(e). A collection of her art essays, *Video Green: Los Angeles Art and the Triumph of Nothingness* was published by Semiotext(e)/MIT Press (2004), followed by *LA Artland*, published in the UK by Black Dog Press. A recipient of the Frank Jewett Mather Award in Art Criticism (2007) and a Warhol Foundation Arts Writers grant (2009), she regularly contributes to *Artforum* and has written for *Texte Zur Kunst*, *Art in America* and *Spike*.

Hanne Lippard
is a writer and designer based in Amsterdam. She was born in 1984 in Milton Keynes, England, and then spent the following years living in various Scandinavian countries. She is currently studying at the Gerrit Rietveld Academie, and although she will be graduating with the title 'Graphic Designer' this year, she is flexible with the designation. It is the use of a narrative which is important in her work, rather than what medium is being used.

Seth Price
is an artist who lives and works in New York.

Laure Prouvost
is an artist and film-maker who lives and works in London. Her work includes painting, video, sound and site-specific works. In recent years she has exhibited at: Lightbox, Tate Britain; Flattime HO, London; BFI, London; Form Content, London; EAST International, Norwich; MOT Gallery, London; CCCB, Barcelona; St Gervais Centre, Geneva; Zoo Art Fair, London; LUX, London and National Media Museum, Bradford. She won the EAST International Award and also completed the LUX Associate Artists Programme (2009).

Stephen Sutcliffe
is an artist who lives and works in Glasgow. He has shown recently in exhibitions at the ICA, London; Glucksman Gallery, Cork; Dundee Contemporary Arts, Dundee; Cubitt, London; Alessandro de March, Milan and was shortlisted for the Derek Jarman Award (2009). Upcoming exhibitions include shows at Rob Tufnell Gallery, London and Galerie Micky Schubert, Berlin.

Sarah Tripp
is an artist based in Glasgow, where she recently received an Open Glasgow commission from the 2010 Glasgow International Festival of Visual Art. She was awarded the Scottish Arts Council's Visual Arts Residency at Cove Park (2009), other recent works include: *Very few of us have windows now* (Gnommero); *Why I can't eat at Asia Style* (2HB vol. 4); *Why I disappeared* (Cove Park); *Let me show you some things* (CCA, Glasgow); *The Best Mistake* (Generator Projects, Dundee); *The Inside of an Ambulance* (Fruitmarket Gallery, Edinburgh); *Why Work?* (Camden Arts Centre, London) and *Testatika* (Cornerhouse, Manchester).

— Back Issues —

Issue 1 'Linguistic Hardcore'
Spring / Summer 2008

Issue 2 'Hunting and Gathering'
Autumn / Winter 2008

Issue 3 'Volatile Dispersal'
Spring / Summer 2009

Issue 4 'A Rather Large Weapon'
Autumn / Winter 2009

Available to order from www.bookworks.org.uk

THE WORST IS NEVER CERTAIN.

The Happy Hypocrite is seeking submissions for future issues.
For more information please visit:
www.thehappyhypocrite.org

DIE KEURE PRINTERS.

— *The Art of Contemporary Printing*

Die Keure Printers
Kleine Pathoekeweg 3, 8000 Bruges, Belgium
Tel. +32 5047 1272 / Fax. +32 5047 1274
info@diekeure.be / www.diekeure.be